Silver Springs

Florida A&M University, Tallahassee

Florida Atlantic University, Boca Raton

Florida Gulf Coast University, Ft. Myers

Florida International University, Miami

Florida State University, Tallahassee

New College of Florida, Sarasota

University of Central Florida, Orlando

University of Florida, Gainesville

University of North Florida, Jacksonville

University of South Florida, Tampa

University of West Florida, Pensacola

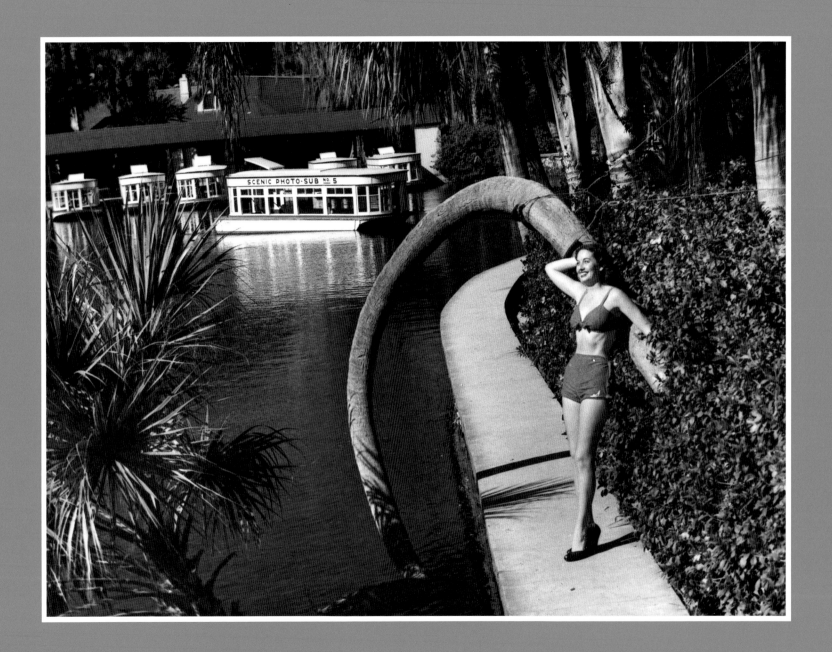

Silver Springs

The Underwater Photography of Bruce Mozert

GARY MONROE · With an introduction by Gary R. Mormino

UNIVERSITY PRESS OF FLORIDA

Gainesville · Tallahassee · Tampa · Boca Raton · Pensacola

Orlando · Miami · Jacksonville · Ft. Myers · Sarasota

Library of Congress Cataloging-in-Publication Data

Mozert, Bruce, 1916–

Silver Springs : the underwater photography of Bruce Mozert / Gary
Monroe ; with an introduction by Gary R. Mormino.

 p. cm.

ISBN 978-0-8130-3220-7 (alk. paper)

1. Silver Springs (Fla.)—History—Pictorial works. 2. Tourism—Florida
—Silver Springs—History—Pictorial works. 3. Mozert, Bruce, 1916–
4. Underwater photography. I. Monroe, Gary. II. Title.

F319.S55M69 2008

975.9'75—dc22

2007031350

The University Press of Florida is the scholarly publishing agency for the
State University System of Florida, comprising Florida A&M University,
Florida Atlantic University, Florida Gulf Coast University, Florida
International University, Florida State University, New College of Florida,
University of Central Florida, University of Florida, University of North
Florida, University of South Florida, and University of West Florida.

University Press of Florida
15 Northwest 15th Street
Gainesville, FL 32611-2079
www.upf.com

Preface & Acknowledgments

The pre–Disney World Florida landscape has all but disappeared. Remnants of "old Florida" are few and far between, off the beaten paths that are not serviced directly by the interstate system. Homogeneity seemingly reigns supreme in the "new Florida," as evidenced by the same fast-food restaurants, bright service stations, and chain drugstores at nearly every intersection. Massive planned communities fill the new suburbs. Tall glass office buildings and condominiums dominate our old cities. Expansive malls and car dealerships have taken the place of parks and playgrounds. The remaining natural landscape is dotted with huge steel power posts and microwave towers. Florida is increasingly being manicured and accentuated with strategically planted iconic palm trees.

Entertainment tastes have also changed in this great state. People gravitate more to the all-encompassing theme parks. Every attraction has thrill rides now; the beauty of nature simply does not offer enough to keep us happily distracted from our everyday lives. This book is filled with entertaining photographs that Bruce Mozert created at Silver Springs, nature's theme park, during a time when fun-seekers were more involved in their own entertainment. As in the case with compelling art, Mozert's photographs challenge us to bring our own perceptions to his images. There is something amusing, haunting, and even perhaps a bit risqué in these pictures that were captured in a bygone era. However, they were good, clean fun when they were made. Today they are testaments to a unique and interesting time in Florida's history. Indeed, these pictures offer us direct lines to the recent past.

I thank Bruce Mozert for his enthusiasm and appreciation for this book. I also thank Evelyn Yorlano, his secretary, who assisted me throughout my research. I am grateful to Bill and Miriam Ray for their tireless responses to my many questions, as

well as for sharing with me their vast knowledge of Silver Springs. Ginger Stanley, Arrilla Jones, and Betty Frazee, who posed underwater for Mozert, generously and enthusiastically shared their stories with me.

I am forever indebted to my editor, Margie Miller, for humbling me in the process of making sense of my obsessive writing, always with good cheer, enthusiasm, and insight. (Seems like there are *two* great women behind every man who writes.) Noted archaeologist James Miller, author of *An Environmental History of Northeast Florida*, among other Florida books, helped with certain facts and offered moral support. Scott Mitchell, director of the Silver River Museum, was generous with information, as was Gail Grieb, archivist at Stetson University's duMont-Ball Library. And I am grateful to Gary Mormino, a leading scholar of Florida history, for gracing this book with his introduction and sharing information with me.

Similarly, my editor at University Press of Florida, Meredith Babb, continues to guide me in spite of having accepted the reins as press director. Such support means a lot to me. In fact, everyone at the UPF has supported all of my projects. Thank you, Lynn Werts, Larry Leshan, Gillian Hillis, and Susan Albury in production; Dennis Lloyd, Romi Gutierrez, Lisa Neugebauer, and Nicole Sorenson in marketing; and Andrea Dzavik in development. Also, I appreciate Louise OFarrell for the smart design of this book.

I am also grateful to Dr. Leslie Hammond, chief curator at the Appleton Museum of Art, for her support of my research and knowing a good thing when she sees it. She is credited for bringing Mr. Mozert's photographs to the museum for his first-ever exhibition.

Mostly I thank my wife, Teresa, and our children, Mathew and Jessica, for allowing me to have extended time away from home. There is no place I would rather be than with them.

Introduction

It is one of America's natural wonders. For thousands of years, humans have marveled at its physical majesty and metaphysical properties. When the twentieth century dawned, it was Florida's most famous place; by the end of the century, it had become a second-tier tourist attraction.

The natural phenomenon we know as Silver Springs resulted from geological forces occurring over millions of years. For most of its natural history, Florida was a seabed. The aquifer, the storehouse for much of the state's drinking water, owes its origins to the marine life that gradually formed the limestone strata. When the oceans retreated during the last ice age thousands of years ago, the now familiar shape of peninsular Florida appeared. Rain filtered through the porous limestone to replenish the aquifer. The vast underground reservoir produced tremendous pressure, releasing the water in spectacular surges at breaks or fissures in the clay and limestone.

No other place in the world can match the spectacular quality and quantity of springs found in Florida. Here, geologists have now identified over seven hundred natural springs, hundreds only recently discovered. Nature has endowed North Florida with a plethora of such treasures. Florida boasts twenty-seven *first-magnitude* springs, a term defining springs that produce a flow of at least one hundred cubic feet of water per second. (A discharge rate of one foot of cubic water per second is equivalent to a body of water one foot deep, one foot wide, one foot long, moving at a rate of one foot per second.) A first-magnitude spring produces at least 65 million gallons of water a day. While other springs rival Silver Springs—Rainbow, Wakulla, Ichetucknee, Wekiwa, Blue, and Weeki Wachee—none can match its grandeur.

The location is significant. Ocala is situated on a strategic eco-divide between the hardwoods of North Florida and the more tropical settings of Central and South Florida. Historically, Marion County was the southernmost section of Florida's cotton belt. It is the southern boundary for kudzu, the fast-growing vine that has bedeviled much of the Deep South. The area abounds in hammocks, sloughs, wetlands, sinkholes, scrubland, and spring boils. Politically, the imaginary line dividing North and South Florida almost always crosses Marion County.

For good reason, early promoters proclaimed Silver Springs as a fountain of youth. Few places boast such natural abundance. Archaeological sites, such as Paradise Park, have documented the presence of wooly mammoths, mastodons, human skeletons, pottery, stone tools, and projectile points. Underwater archaeologists have explored the headsprings, while the middens have yielded Paleo-Indian artifacts. Silver Springs served as a crossroads waterway, allowing Native Americans to canoe and portage across the peninsula.

The native peoples treasured the waters and lands surrounding Silver Springs. Capt. John T. Sprague, in his 1848 history, *The Origin, Progress, and Conclusion of the Florida War*, noted that Arpeik, an elderly Miccosukee chief, "lived at Silver Spring, near Fort King, and was known as Sam Jones the fisherman. He declared himself a prophet and a great medicine-man. He planned war parties for the young warriors."

In 1825, the U.S. government constructed Fort King, a military outpost, about two miles from Silver Springs. An 1827 letter to Gen. Thomas Jesup confirms the strategic importance of the site. Lt. F. D. Newcomb informed Jesup, "A road is already opened to the spot intended for a landing, and the opening of this branch to its confluence with the Oklawaha . . . to be navigable for large boats & barges." Newcomb added, "The water is so pure & clean, that when the surface is unruffled, at the depth of 37 feet the most minute object may be discovered, even to the smallness of a pin."

In 1826, Col. Gad Humphreys summoned Florida's Indians to Silver Springs. He hoped to find an Indian leader with whom the U.S. government could negotiate. Maj. Gen. George McCall participated in this last memorable gathering of Seminoles and Miccosukees, estimated at three thousand strong. He also wrote in his memoir of "a visit to the Silver Spring, one of the great natural curiosities of Florida." McCall, Humphreys, and a comrade discovered an Indian canoe fashioned of cypress. Their experience has been preserved in McCall's letters:

> Into this egg-shell, nine feet long and two feet wide at the middle, we entered. . . . O! how my heart swelled with astonishment as we neared the centre of this grand basin of limpid water. Think of a body of water coming from under a limestone bluff of rugged front, in volumes of almost incalculable bulk, and filling a deep rocky cup of oval form. . . . What an impression. . . . Were not the canoe and its contents obviously suspended in mid-air, like Mahomet's coffin? . . . We seemed to be enclosed within a great magic frame. . . . The dividing line between the air and water is imperceptible when both are at rest.

The Second Seminole War served as a watershed event for Native Americans and Florida. By 1842, most of the Indians had been eradicated or removed, opening the peninsula to settlement. On the eve of statehood in 1845, James Powers purchased from the U.S. government an 80-acre tract of land surrounding Silver Springs for $1.25 an acre. As settlers poured into the region, they quickly realized the importance of Silver Springs as a transportation hub. From Silver Springs, Floridians could ship goods to Palatka and Jacksonville via the Ocklawaha and St. Johns rivers.

The Civil War may have seemed far removed from the isolation of Silver Springs, but the conflict touched the inhabitants. The locale may have actually benefited from the maelstrom, as deserters and refugees sought to escape or profit from the conflict. While saltworks along the Gulf Coast could easily be discovered

and destroyed by marauding Union vessels and troops, sugarcane grown in Marion County and shipped north was almost impossible to stop. Florida cane syrup became even more precious after the Union occupation of Louisiana. A letter from a Confederate soldier stationed near the Silver Springs run and the Ocklawaha River (the river has been spelled many ways over time) has been preserved. He praised the area's fecundity, noting "Silver Springs is a depot for sugar syrup which is sent down the river on a steamer to the railroad and thence across to Waldo." A steamer bearing the name *Silver Springs* also transported precious hogsheads of cane syrup to market.

In December 1856, Dr. Daniel Garrison Brinton explored the springs. A physician, archaeologist, and anthropologist, Brinton recorded his experiences in an 1859 book, *Notes on the Floridian Peninsula: Its Literary History, Indian Tribes, and Antiquities:*

> To be appreciated in its full entirety, it [springs] should be approached from the Ocklewaha. For more than a week I had been tediously ascending this river in a pole-barge, wearied with the monotony of the dank and gloomy forests that everywhere shade its inky stream, when one bright morning a sharp turn brought us into the Pellucid waters of the Silver Spring Run. . . .
>
> But far more strangely beautiful than the scenery around is that beneath—the subaqueous landscape. At times the bottom is clothed in dark-green sedge waving its long tresses to and fro in the current. . . .
>
> What wonder that the untaught children of nature spread the fame of this marvelous fountain to far distant climes, and under the stereoscopic power of time and distance came to regard it as the life-giving stream, whose magical waters washed away the calamities of age and the pains of disease. (184–86)

Another early account was written by John Sanford Swaim, a prominent Methodist Episcopal minister who migrated to Florida in 1864 to assist freed slaves. Writing home to the *Newark Daily Advertiser* in 1866, Swaim described a primitive

Florida occupied by moonshiners, Crackers, and desperate freedmen. But he also wrote in awe of the wonderment of Silver Springs.

> Out of wide chasms in the limestone rock . . . [surge] abundant waters with perfect naturalness; so pure and transparent that a sixpence could be seen distinctively. . . . When one looks down into these depths with his back to the sun, the most gorgeous prismatic colors are seen in every possible shade, constantly changing like the flashes of the Aurora Borealis.

A Vermont transplant, Hubbard Hart, made it possible for other Americans to travel to Silver Springs by more efficient and commodious ways. Arriving at Palatka in 1854, Hart quickly realized the commercial possibilities of promoting the springs to travelers and tourists. He invested in sawmills, hotels, and steamships. In 1866, the State of Florida awarded Hart a contract to clear the Ocklawaha River channel for navigation purposes. It would not be the last time the government attempted to "improve" the Ocklawaha.

From the wreckage of the Civil War, Florida emerged as a tropical paradise. Seemingly oblivious to the political turmoil that gripped the state during Reconstruction, Yankee tourists soon appeared in Jacksonville, eager to see unspoiled Nature. The era of the steamboat had arrived. Jacksonville became a major point of embarkation for travelers destined for Silver Springs.

Specially designed steamboats were built for the purposes of navigating the narrow and twisting stream. Stern-wheel vessels such as the *Lollie Boy, Silver Springs,* and *James Burt* acquired a legendary reputation for their ability to transport passengers and cargo from Palatka to Silver Springs, a two-night, one-day trip. Passengers routinely shot and blasted away at anything that moved in the water and riverbank. The wildlife was unsurpassed, as flocks of parakeets, passenger pigeons, mockingbirds, and red-cockaded woodpeckers covered the river canopy.

The golden age of Silver Springs coincided with America's Gilded Age. The quarter century following the Civil War was characterized by explosive growth and

the rise of great fortunes and ostentatious living. In the North, the rich and idle built summer estates in Newport and Saratoga Springs. The middle class "rediscovered" America, and the era of modern tourism began.

But for most Americans, Florida was inaccessible and remote. Only the wealthy could afford the time and expense required to vacation in Florida. Henry Plant and Henry Flagler erected lavish hotels along the Atlantic and Gulf coasts. Patrons found few luxuries at Silver Springs. As late as 1880, the "resort" boasted a single hotel and a few stores. Determined travelers departed Jacksonville by steamer for Palatka. Following an overnight voyage, visitors encountered Silver Springs the following morning, a trip of more than one hundred miles.

Silver Springs became an almost irresistible stop for those travelers who made their way to Florida. Most had already read a great deal about the place. Perhaps no other site in Florida has attracted as many prominent writers and intellectuals as Silver Springs.

Harriet Beecher Stowe was the era's most famous Florida resident. She settled in Mandarin and fell in love with her adopted state. But even Stowe drew the line. Hoping to visit Silver Springs, she refused to board the steamship *Ocklawaha*. She described her displeasure in the *Christian Union* (1873): "We had always dreaded the boat as the abatement of pleasure." Moreover, she thought the ungainly vessel resembled a "coffin in the twilight." Yet when she finally arrived at the springs, she proclaimed, "There is nothing on earth comparable to it." In *Palmetto Leaves* (1873), Stowe gushed that even if she and her fellow travelers had seen Europe's treasures, "never, but never have they in their lives seen aught so entrancing as this."

A Who's Who of travel writers left accounts of their odyssey to Silver Springs, nearly exhausting every superlative in the English language. Edward King's *The Great South* (1875) recounted his 25,000-mile tour of the South. He understood why, in the early 1870s, 50,000 tourists were determined to make their way to this

modern fountain of youth and "fairy spring" each year.

In 1880, Abbie M. Brooks, aka Sylvia Sunshine, introduced Florida to American readers in her book *Petals Plucked from Sunny Climes*. Complaining that the accommodations aboard the steamboat *Marion* were "harder than Pharaoh's heart," Miss Sunshine conceded that Silver Springs was worth the aggravation.

> On a bright day the beholder seems to be looking down from some lofty air-point on a truly fairy scene in the immense basin beneath him—a scene whose beauty and magical effect is vastly enhanced by the chromatic tints with which it is enclosed.

Arguably the most acclaimed travel writer in this talented group was Sidney Lanier. Employed by a railroad to extol the virtues of America's southernmost state, the once dashing poet-musician of the Old South, although dying of consumption, managed to complete his road book. *Florida: Its Scenery, Climate, and History* (1875) is regarded as one of the classic guidebooks. Approaching the "irruption of the Silver Spring," Lanier announced, "Here new astonishments befell. The water of the Ocklawaha, which had seemed clear enough, now showed but like a muddy stream as it flowed side by side, unmixing for some distance, with the Silver Spring water."

Florida's wild interior rivers especially captivated Lanier. His description of the Ocklawaha may be the greatest single sentence in Florida literature:

> The sweetest water-lane in the world, a lane which runs for more than a hundred fifty miles of pure delight betwixt hedgerows of oaks and cypresses and palms and bays and magnolias and mosses and manifold vine growths, a lane clean to travel along for there is never a speck of dust in it save the blue dust and gold dust which blows the wind out of the flags and lilies, a lane which is as if a typical woods-stroll had taken shape and as if God had turned into water and trees the recollection of some meditative ramble through the lonely seclusions of His own soul.

In 1880, the steamboat *Osceola* ferried the most celebrated group of passengers ever to explore the interior. President Ulysses S. Grant led a party of citizens from

Fernandina to Silver Springs, and then on to Cuba and Mexico. The delegation included Frank Hamilton Taylor, artist and reporter for *Harper's Weekly*, General and Mrs. Philip H. Sheridan, and writers from the *New York Times* and *Philadelphia Times*.

In 1889, the Silver Springs, Ocala and Gulf Railroad brought passengers to Ocala, succeeded by the wood-burning engines of the Ocklawaha Valley Railroad.

The proprietors of Silver Springs began to promote the attraction to mass audiences in the early twentieth century. Glass bottom boat rides and the obligatory postcard became a signature part of the tourist experience. Millions of Americans saw firsthand the "Bridal Chamber," the deepest of the wellsprings. Steamboats plied the waters of the Ocklawaha and Silver rivers long after they had become obsolete in other locales. By 1916, a smooth, crushed limestone road allowed tourists to drive to the attraction. The timing was critical, as a new generation of "Tin Can tourists" headed for Florida in their Ford flivvers after World War I. During the Gilded Age, only the wealthiest Americans could afford the time and expenses of steamboat and hotel; by the 1920s, the middle classes had discovered the joys of Florida motor courts and cruising the newly built highways.

As the numbers of tourists increased, so did the refinements at Silver Springs. Financiers erected the Silver Grill in the 1920s, a popular dancing and dining establishment. Gasoline and electric motors replaced human-powered oars and steam engines.

Cursed and driven from Silver Springs in the 1820s, Seminole Indians returned a century later as capitalists and curiosities. Seminoles from the Big Cypress reservation became an exotic tourist attraction at Silver Springs, the northernmost "village." There, they reintroduced Indian crafts and introduced alligator wrestling. Still, Seminoles eked out a bleak existence at their Silver Springs village. On Thanksgiving Day 1935, an advertisement promised tourists free admission if they brought "used clothing for the Indians."

The Florida WPA guidebook, published in 1939, itemized the lively traffic in reptiles. Baby crocodiles and alligators sold for $3 and 25¢, respectively, while rattlesnake oil commanded $1 an ounce. Not even America's most catastrophic economic crisis, however, kept the crowds away from Silver Springs. A 1935 *Tampa Tribune* headline announced, "Silver Springs Wins Claim as No. 1 Lure." A half million Americans could not be wrong.

The onset of World War II and gas rationing posed an even greater obstacle to tourists. But millions of servicemen, spouses, and workers made Florida their new home during the war. Military bases, such as Camp Blanding and Jacksonville Naval Air Station, dotted North and Central Florida. An estimated 200,000 GIs, anxious to see the much ballyhooed attraction, managed to hitch a ride or arrive in military buses and trucks to enjoy the park at reduced prices.

The end of World War II ignited one of America's great leisure booms. Every GI, it seemed, wanted to get married, get a job, and enjoy a Florida vacation. The increase in tourist traffic was remarkable. Silver Springs was drawing 800,000 tourists by 1949. The source and resource seemed inexhaustible. Why would Americans ever *not* want to bring their families to such a serene and lovely place?

The number of attractions also grew in variety and number. As wave after wave of new tourists arrived in new high-powered, postwar cars, Silver Springs now offered customers jungle cruise speedboat and "submarine" rides. Ross Allen, one of Florida's great characters and promoters, opened his world-famous Reptile Institute in 1929, astonishing large crowds with his famous rattlesnake milkings and snake charming. On Emancipation Day 1949, Paradise Park opened, offering middle-class African Americans the same pleasures, albeit segregated, as white patrons.

Nothing, however, magnified the popularity of Silver Springs as the silver screen. Beginning in 1916 with the filming of *The Seven Swans*, the movie industry has enjoyed a love affair with Silver Springs. In 1929 Grantland Rice filmed *Crystal Champions*, a series of short subjects introducing Johnny Weissmuller and

other Olympic swimmers. The handsome champion returned to make six popular Tarzan films. Newt Perry, a former Silver Springs lifeguard, appeared in many of the early films. He played a black-faced African tribesman and wrestled with alligators. Grantland Rice once described the former University of Florida athlete as the greatest swimmer he had ever seen. In 1947, Perry opened a rival establishment on the Gulf Coast of Florida, Weeki Wachee Spring. There he introduced the now famous mermaids.

Hollywood directors cast Silver Springs as everything from African jungles and ocean lagoons to luxury resorts and backwoods Florida. The much anticipated movie *The Yearling* (1946) was filmed on location, although critics complained that Rawlings's novel should have been set in the austere scrub, not in the lushness of Silver Springs. In 1951, the site doubled as the Everglades in *Distant Drums*, a Seminole War adventure starring Gary Cooper. Filming brought fame and notoriety to Silver Springs; it also left behind extras—wild monkeys that have roamed the grounds for six decades.

Lured by promotion and fueled by prosperity, Americans by the millions poured into Florida, destined for attractions such as Cypress Gardens, Marineland, and Wakulla Springs. Silver Springs was a dream machine, benefiting from film, television, and millions of "See Silver Springs" decals attached to car bumpers and birdhouses. Few could have imagined that the 1960s would represent the apogee of this much vaunted attraction.

The opening of Walt Disney World in 1971 changed everything. Soon tourists whisked by the once prestigious establishments, headed to Orlando on the new interstate highways or jet planes. Even though Silver Springs was only a short jog from Interstate 75 and the Florida Turnpike, it suffered from an image problem, as did many older Florida attractions. The Ocala opening of Six Gun Territory in 1963 was short-lived. Its closing in 1984 was preceded by the demise of the Florida Reptile Institute, Deer Ranch, and the Early American Museum.

An industry shakeup shook up even the granddaddy of Florida's tourist attractions. Silver Springs went through a series of owners. The American Broadcasting Company, the University of Florida, Florida Leisure Acquisitions, the Ogden Corporation, and the State of Florida have all been involved in ownership during the most recent decades.

To earlier generations of Americans unaccustomed to animatronics and computer graphics, nature was once enough. One by one, some of Florida's great gardens have closed their doors, victims of new tourist economies and tastes. The public adored places like Silver Springs because it was pure, wholesome, and unspoiled. Disney World represented a triumph of technology and hype over nature and authenticity. Who needs the real Silver Springs when promoters in the 1970s could erect Wild Waters, a high-tech complex of water slides, flumes, and pools built a few miles away?

Environmentalists express alarm over the fate of Silver Springs. Dire warnings are not new. Originally, a marsh surrounded the main spring, ideal for a spawning ground for fish and nesting for birds. Development has erased the marsh. Until 1936, a species of freshwater shrimp (*Macrobrachium jamaicense*) flourished in the spring waters. The depletion of the aquifer has resulted in a significant decrease in the discharge of water at all of Florida's great and lesser springs. Agricultural runoffs, the reliance upon septic tanks, and the popularity of water sports and boating have diminished the quality of what was once some of the purest water in the world. The Southwest Florida Water Management District concluded that the nitrates in the spring water had tripled since the 1950s. Environmentalists, politicians, and health officials clashed over what to do with the wild monkeys, extras left over from the Tarzan movies.

The greatest threat to the sanctity of Silver Springs and its intricate eco-system came in the 1960s. For decades, North Florida politicians had attempted to build a canal across the state. U.S. senators Duncan Fletcher and Claude Pepper argued that

the canal would create much-needed jobs, make unnecessary the long trip across the Straits of Florida, and provide American freighters a safe harbor against German U-boats. Neither the Great Depression nor World War II could induce Washington lawmakers to finance the audacious plan. In 1964, President Lyndon B. Johnson signed the bill and pulled the lever to begin the controversial Cross-Florida Barge Canal. The canal's route stretched from Jacksonville to Palatka to Yankeetown.

Engineers proposed transforming portions of the Ocklawaha River—called by Victorian writer Edward King a place of "sylvan peace and perfect harmony"— into a dam. Author Mark Derr points out, with irony, that "nearly a century after [Lanier's] *Florida: Its Scenery, Climate, and History* first appeared in print, environmentalists used the opening chapter on the Ocklawaha and the voyage of the *Marion* to bolster their case against the Cross-Florida Barge Canal." The U.S. Army Corps of Engineers appreciated neither the historical irony nor the growing environmental movement. Ignoring the mounting protests, the project went forward. The dredge replaced the steamboat as symbol of the Machine in the Garden. The winding Ocklawaha confronted the Rodman Dam. Marjorie Carr, a Gainesville biologist, founded Florida Defenders of the Environment to oppose the project. Environmentalists lost the battle but succeeded in killing the troubled barge canal. In 1971, with the urging of Florida governor Claude Kirk, President Richard M. Nixon issued an executive order halting the project. The canal did not die easily. In 1976, the Florida legislature requested that the U.S. Congress stop construction. Congress complied. The Rodman Dam still stands and ecologists still grieve for the Ocklawaha. The project was not officially killed until the 1990s.

Daily growth threatens the serenity of North-Central Florida. Ocala and Marion County have exploded in recent decades. In 1950, Marion County had a population of 38,187 sprawling over a huge land mass of 1,663 square miles. In 2006, the county's population surpassed 300,000. Environmentalists and political scientists point to Marion County as a poster child for growth management. Sprawl in the

form of mobile home parks, strip malls, and low-density growth has characterized rampant growth.

Water—or the scarcity of it—has become one of the salient issues for Floridians. In its simplest form, North Florida has it, and South Florida wants it. For most of the state's history, water was a problem: how to drain the Everglades and make the cursed swamp productive; how to make the wetlands dry for progress and development. In 1870, when the first wave of modern tourists arrived by steamboat on the Silver River, the state contained 188,000 residents. Today, Florida gains that many new residents every six months. Its 19 million residents and 80 million tourists have an unquenchable thirst. In 1870, indeed, as late as the 1950s, if developers or industrialists had wished to build a pipeline from Silver Springs to supply the water needs of Central Florida, politicians would have gladly granted the request. Considering that each day Florida springs collectively discharge 7 billion gallons of water, they remain vulnerable and valuable. Each future generation of Floridians must learn to appreciate Silver Springs on its own terms.

Growth in one of America's fastest-growing regions poses an enormous problem for Silver Springs. Since the 1980s, the Coral Gables–based Avatar Properties has planned an 11,000-home development, with blueprints for three shopping centers, a million square feet of commercial space, and a golf course. Ocala Springs would be located just a mile north of Silver Springs. The site contains thirteen sink holes and habitat for black bear. But in December 2006, the State of Florida, the Nature Conservancy, and Marion County came together to jointly purchase 4,471 acres (nearly seven square miles) from Avatar Properties for $76 million. "The land will now be set aside for conservation and recreational use by future generations of Floridians," rejoiced the *Ocala Star-Banner*. "It is a victory of immeasurable environmental proportions for Marion Countians." And all Floridians!

Silver Springs endures!

Gary R. Mormino

Silver Springs was the number one attraction in the state of Florida

and was the underwater capital of the world.

—Bruce Mozert

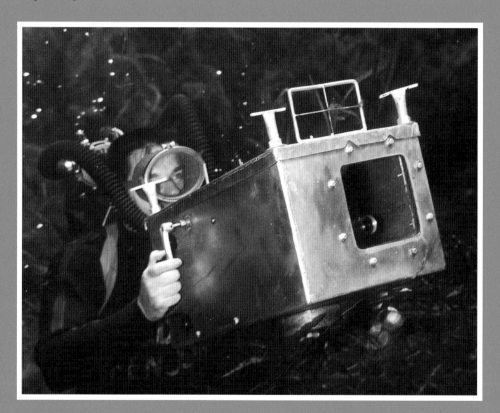

The Underwater World of Bruce Mozert

With the advent of paddle-wheeled steamboats in the late nineteenth century, Silver Springs became a mecca for travelers seeking to commune with nature, but it was the invention of the glass bottom boat that established it as a renowned tourist attraction. Of course, the mere novelty of sight below the surface of the water attracted many, but here one also could gaze in awe at the aquatic life that dwelled in the springs. However, thousands of years before this area became a tourist attraction, these waters nurtured Native Americans. Indeed, because the main spring is a first-magnitude spring, in all likelihood this was a fresh water source even in glacial times. Here, in one of Florida's most important Paleo-Indian locations containing cultural and fossil remains, archaeologists and divers have found mastodon bones and stone tools, some of which are ten thousand years old.

Throughout history, the springs beckoned people to this area. Hernando de Soto and his company passed through in 1539, pausing briefly for an encounter with the Ocali Indians before heading north in their quest for silver and gold, seemingly undeterred by the surrounding natural beauty. For thousands of years, Timucua Indians lived at the spring and throughout northeast Florida, but like nearly all of the state's native people, they were decimated by European disease and warfare by the early 1700s. Seminole Indians from the Creek tribes in Georgia and Alabama filled the void for a century or so, but by the 1840s they had been driven south to their last stronghold in the Everglades. A decade later, commerce came to Silver Springs when African American slaves poled barges with sugar, cotton, lumber, and nonperishable goods on the five-mile-long Silver River into which the springs flow. Further, through the twisting Ocklawaha River, they moved on into the St. Johns River, traveling to Palatka, which was then the central hub of river traffic in Florida.

Bruce Mozert using one of his early underwater housings to film at Silver Springs.

According to historian Carita Doggett Corse, Silver Springs got its name from those earliest settlers who called it *Sua-ille-aha*, meaning "sun glinting water." Powerful springs flow here from ancient crevices into common basins, filling them with clear sky-blue water. The pool of the largest spring is 300 feet across from north to south and 195 feet across from east to west. Its depth over the vent openings is 33 feet. Every second, Silver Springs discharges an average of 820 cubic feet of water. In 1944, it was possible for daily flows to measure at a billion gallons. However, in recent times, the wellheads are more likely to send only 500 million gallons of pure and clear 72-degree water to the surface after flowing around vibrant aquatic life and through the waving forests of eelgrass.

Rainfall that charges the springs is filtered as it passes through a massive limestone stratum. The water becomes so clear that light refracts into prismatic colors. The clarity, together with the lime that is absorbed by the water and broken on the surface, gives the springs an iridescent luster. The bottom at one time was an undulating floor of fish before it was compromised by nearby development. It is a truly magical setting, making distant objects in the springs appear to be inches away.

In the 1850s, Hart Line stagecoaches connected Silver Springs to Tampa and Palatka. Hubbard Hart hired James Burt in 1860 to bring steamboats to Silver Springs, thereby bringing more tourists into the interior of Florida. People would arrive in a steamboat from Jacksonville that first traversed the St. Johns River, then turned down the Ocklawaha River to the Silver River, and finally proceeded onward to Silver Springs. Often these trips were made at night with a bucket of pine knots burning on the bow, lighting the way while romantically motivating sightseers to become explorers. Silver Springs at that time often attracted invalids who sought rehabilitation here, but it also had become a respite that offered spiritual sustenance to those in need of it. In 1881, T. Brigham Bishop built a 200-room hotel for these sojourners by the headwaters; here tourists could enjoy the largest known artesian spring in the world.

This picture, made before 1955 when a fire destroyed the buildings, shows the bathing beach in the foreground and the boat docks in the background, with both glass bottom boats and photo subs cruising over the main spring. The diving tower had a ten-foot-high diving board and a twenty-foot-high diving platform. Bruce climbed a very tall cypress tree by nailing strips of pine boards for steps up the trunk to take this picture.

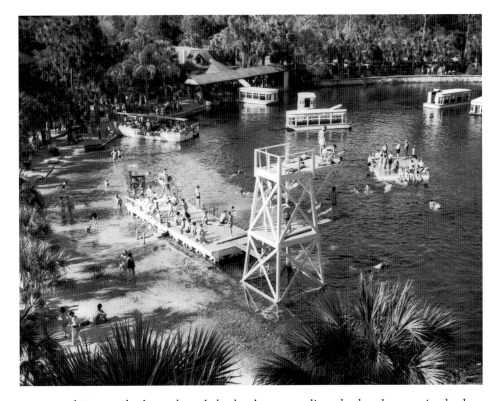

Samuel Howse had purchased the land surrounding the headwaters in the late 1860s. The area was described then as "one of the wonders of the world," a setting "more luxuriantly beautiful than the poet's wildest dream," luring people from around the world. However, as Richard A. Martin explains in *Eternal Spring: Man's 19,000 Years of History at Florida's Silver Springs*, "Many who rode the Hart Line steamboats to the springs in the 1880s and 1890s were more interested in the ride than in the view of Silver Springs at the end of the line." He quickly adds, though, that the primitive beauty of the place changed many visitors into talking advertisements for Silver Springs, thereby disagreeing with those who said that it was "no more than a picturesque pool tucked away in a remote Florida forest." With the

coming of the glass bottom boats, visitors here would be offered an intimate look at an underwater world. Henceforth, Silver Springs, as a destination, became more appealing and more important than the journey that was taken to get there.

The exact date of the invention of the glass bottom boat cannot be confirmed. None of the self-generated or anthologized literature about Silver Springs that was published through the 1870s mentions these boats. The Web site for Silver Springs says that Hullam Jones invented the glass bottom boat there in 1878 when he installed "a glass viewing box on the flat bottom of a dugout canoe." However, to confuse this issue further, the same Web site goes on to list Phillip Morell, who was a lifetime resident of Silver Springs, on its historical timeline, saying that Morell had built a glass bottom rowboat in the late 1870s. There is one cited fact in the Morell credits that is different from the Jones credits, apart from the point that Jones had used a canoe and Morell had modified a rowboat. Perhaps this is the fact upon which the inventor controversy turns: Morell charged patrons for a ride in his rowboat. But longtime residents attest that *glassless* flat-bottomed rowboats were used for touring the springs until young Morell constructed a well in the bottom of his rowboat, to which he affixed a glass pane. Bill Ray, whose family both owned and leased land in the park during his younger years, steadfastly identifies Morell as the inventor. He adds that he and others with personal ties to Silver Springs never knew or heard of Hullam Jones. When Bill Ray was a young man, he met Phillip Morell; Ray's elders introduced Morell as the man who had invented the glass bottom boat.

Nevertheless, Oliver Howse, who ran a bathhouse and rented rowboats at the springs, claimed that the glass bottom boats were not present in the 1880s. Suffice it to say that the glass bottom boat was invented and in use in Silver Springs before the turn of the twentieth century. In 1903, H. L. Anderson, who had purchased the springs and surrounding land from Samuel Howse in 1898, sued the Seaboard Air Line Railroad for allowing Morell to use their docks for his sightseeing boats. It

Carl Ray (*left*) and "Shorty" Davidson (*right*) receiving an award. MacDonald Bryan, president of the Florida Publicity and Public Relations Association, declaring Silver Springs' wartime advertising and public relations program to have been the best in the nation.

Note the mural of Silver Springs's iconic image positioned as a backdrop. As was typical, advertising companies' logos are prominent. Mozert made numerous murals and generally washed the processing chemicals from the prints in the spring's run.

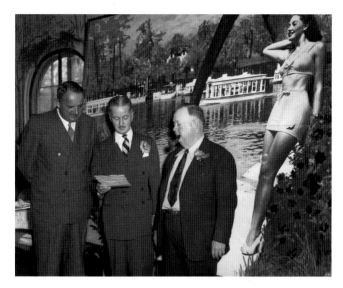

seems that Morell's boats were proving to be very popular, cutting into the revenue that Anderson derived from his own glass bottom boat concession, which was installed soon after he acquired the park. In 1908 Anderson sold 80 acres around the springs to Ed Carmichael, who eventually installed cushioned seats and canopies on the boats to make tourists more comfortable as they were rowed across the water's surface.

With the leasing of the springs to Carl Ray and W. M. "Shorty" Davidson in 1924, the attraction entered into its period of modern history. Ray and Davidson were driven men, determined to make Silver Springs bigger and better. They made a pact: for ten years, neither of them would draw a salary. The only money they agreed to take from the business was for Ray's cigarettes and gasoline and for Davidson's pipe tobacco and gasoline. Carl Ray's son, Bill, says that his father joked that he had gotten the better deal because cigarettes cost more than pipe tobacco. All other revenue went back into the business, much of which was earmarked for the advertising that ultimately became the impetus to Silver Springs's success.

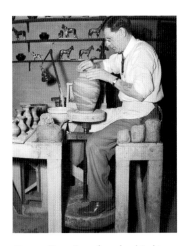

Henry Graack at the wheel in his pottery shop. Graack came from Denmark and was a third generation potter. His store was along the arcade of shops that fronted the glass bottom boat docks. He threw his clay vases and bowls in front of a sign reading WATCH THE POTTER AT WORK. Enthralled visitors did, and for 31 years, they took home pottery, marked "Silver Springs, Fla.," for as little as one dollar apiece. Graack would regularly mix orange blossom perfume into the clay to scent his vases and bowls to further remind northerners of their Florida vacation.

During the following year, in 1925, Ray and Davidson replaced the paddles of the glass bottom boats with gasoline engines. Because admission to the park was free, shops and displays were established to complement the serene beauty of the springs and to entice people to spend their money. Herpetologist Ross Allen arrived with twenty-two snakes and fifty dollars with which he started his renowned Ross Allen's Reptile Institute in 1929; he also established a Seminole Indian Village on the park grounds. Colonel Tooey, who operated the Jungle Cruise boat ride, was responsible for importing rhesus monkeys from Southeast Asia in an effort to enliven the environment. As time passed, the nonindigenous swimming primates left the island reserve to take up residence in the river's swampy forest where they, to this day, exchange stares with passing boaters. Henry Graack Jr. threw clay pottery at his Silver Springs studio from 1935 until his death in 1966.

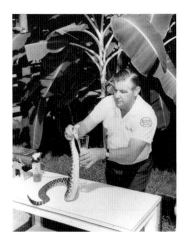

Ross Allen extracting venom at his Ross Allen's Reptile Institute, a primary attraction at Silver Springs. With paid admission to the Reptile Institute, visitors joined a group that would be led past different exhibits, which included huge alligators, monkeys, and birds. Guides milked snakes every hour when they weren't catching small alligators and turning them over to "put them to sleep," amazing the spectators. The guides also carried a harmless snake for patrons to handle. Visitors could have their pictures made while holding the snake. The tour included the Seminole Indian Village where the women ground corn and sewed their unique clothing. Visitors exited through the ever-present gift shop that sold alligator products as well as the usual tourist merchandise.

In addition to the showmanship, Allen processed venom there and sold it to labs for the making of antivenin. There was also a cannery here where rattlesnake meat was processed.

Paradise Park, the park built for middle-class African Americans, opened in 1949. Segregated from the main Silver Springs Park, it had its own building, which contained a gift shop, soda fountain/lunch room, and a bathhouse with available lockers and towels. Picnic tables were scattered about for use by the patrons. There was a white sand beach on the Silver River where visitors could swim. General admission was free, and the boat rides, which covered the same areas as those leaving from the main park, were half the cost to white guests. Ross Allen's concession was also open to these tourists. According to its publicity brochure, Paradise Park was "regarded by prominent civic, business, and religious leaders throughout the nation as the finest thing of its kind ever built for members of their race."

The revenues of Cypress Gardens, Weeki Wachee, Marineland, Seaquarium, Alligator Farm, Parrot Jungle, and Monkey Jungle trailed far behind those of Silver Springs during its golden era. This is especially noteworthy when one realizes that Silver Springs did not have anything akin to water ski shows, alluring mermaids, dancing porpoises, jumping whales, hungry gators, or exotic birds and animals. It had, in fact, *nothing*. It offered only "Nature's Underwater Fairyland." It was distinctly Floridian, a resource-based attraction.

Billed as "Florida's Original Tourist Attraction," Silver Springs differed from other attractions around the state from its very beginning. Its appeal was beneath the surface of those waters that were surrounded by unspoiled and unfettered nature. Although management charged visitors a fee for riding in the glass bottom boats, general admission to the park was gratis and hence ever-inviting. With a meager 10 percent claim to the earnings of the rent-free vendors, the administration needed to attract many, many tourists who would be willing to spend money on food, souvenirs, and sightseeing.

The shops at Silver Springs brimmed with souvenirs. In fact, if eBay is a fair indicator, Silver Springs sold more key chains, decorative spoons, and assorted tchotchkes than the competition. Throughout the park, but especially around these

Downstream from Silver Springs, segregated Paradise Park was staffed by African Americans. Eddie Vereen was the manager since its opening on Emancipation Day 1949. Events and meetings were held there, along with leisure activities. Blacks rode the glass bottom boats, but the rides were not integrated. They enjoyed the same route and at half the price.

Paradise Park closed because it was no longer able to support itself. According to Bill Ray, "Times and people changed and integration replaced segregation. It was unusual to set up a black enterprise supervised and staffed by blacks in those days. It was appreciated by the black community when it began. It demonstrated black integrity, ability, and work ethic. Mr. Vereen was a good example for anyone to follow."

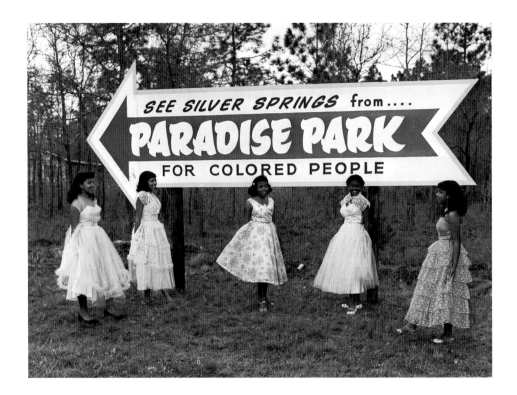

stores, benches were strategically placed so that shoppers and visitors could rest and recuperate. Management knew that if one person in a group of guests complained of fatigue, the entire party was apt to leave.

At the height of Florida's postwar boom, Silver Springs achieved national attention through the efforts of a remarkable in-house publicity machine. In 1951, amid Silver Springs's banner years, Bill Ray organized the publicity department. He was the chief publicist, the behind-the-scenes star, orchestrating images for mass consumption. Says Ray, "The people we employed were super people, wonderful people. It was a magic time. Everyone looked forward to coming to work, to coming up with ideas."

Silver Springs's travel brochures had to point out that there was no underwater mermaid show here to delight visitors. The publications had to clarify for potential visitors that the park did not offer an adventure like the Everglades, where one could fly over the river of grass in a nearly out-of-control airboat and risk being eaten by alligators. A trip to Silver Springs was more like a trip to the Grand Canyon, where one could look in wonder at God's creation.

However, Silver Springs provided something that the Grand Canyon could not: viewing one of God's creations that was underwater. In addition to the glass bottom boats, the Aquatorium was constructed to allow visitors yet another vantage point from which to observe the underwater life. Using concrete for its ballast, together with steel and glass, the Aquatorium was constructed a half mile away from the main spring. Upon completion, this structure was slid down the riverbank on bananas, a natural and eco-friendly lubricant. From there twenty motorboats pulled it upriver into position. There was no charge for a visit to the Aquatorium if one had already purchased a ticket for a glass bottom boat ride. Carl Ray wisely subscribed to the tenet that "when people got their money's worth, they told others and came back again."

In the early 1950s, the Sunshine State witnessed the building of new motels along the highways that led to its beaches and the construction of modern hotels beside its coastlines. In those days, most routes to either coast passed through centrally located Ocala, carrying young and old adventure-seeking tourists. Appealing especially to the vacationing families passing through neighboring Ocala, Silver Springs Park had stated in all of its marketing brochures that it "does not permit the sale of liquor, wine or beer on its premises, nor is gambling permitted in any form." During the war years some 200,000 soldiers on active duty had visited here, only to return with their young families to this wholesome place.

An average of 500,000 people annually visited the park back then; some years even more. Billboards and advertising signs reached all the way to Maine. One

such ad appeared in Times Square. The billboards usually had colorful drawings with a narrative that highlighted the glass bottom boat rides, but one simply read C SILVER SPRINGS. Bulletins and small printed signs were placed in various cities around Florida. Ten thousand heavy rubber doormats advertising Silver Springs were distributed to motels, giving traveling families something to dream about during the night. "You couldn't go to a motel or courtyard in Florida without seeing a Silver Springs doormat," claims Bill Ray. Silver Springs postcards in five languages—Portuguese, German, French, Spanish, and English—declared it "Florida's International Attraction." These postcards were cheaper than any others, thereby encouraging more mailings while providing free worldwide advertising.

By the early 1940s, Silver Springs Mileage Meters, analog predecessors of MapQuest, were introduced to the traveling public. Initially, until people found a way to use the breadbox-sized devices for gambling, they were given without charge to service stations and motels. Using the meters righteously, travelers would turn a drum wheel to garner the distance from their present location to the next destination, together with the preferred route to get to that point. Although businesses eventually had to buy these gizmos and then protect them from the abuse rendered by small-time gamblers, the meters remained a popular commodity; they freed clerks from repeating directions and explaining landmarks, thereby saving them valuable time in which to peddle the wares of their employers. Originally each meter casing was identically manufactured from metal, but by the late 1950s they were cast from plastic. However, the sheath of information attached to the drum had to be customized for the town in which it was placed. Every unit carried the reminder DRIVE SAFELY AND SEE SILVER SPRINGS.

In spite of its lack of glitz, or because of it, Silver Springs was Florida's premier tourist attraction until the coming of the megacorporate theme parks. Because the beautiful, foreign life in the "99.8% pure water" was advertised through great marketing techniques and unique promotional photographs, the park's popularity as a

tourist destination soon swelled. The ingenious publicity team exploited every opportunity. When oil companies stopped giving away free road maps, Silver Springs started printing maps in their brochures. After families returned to their cars from a visit to the park, they would discover a sticker affixed to their chrome bumpers which read, DON'T MISS FLORIDA'S SILVER SPRINGS! The *Orlando Sentinel* once claimed that, judging from the abundance of these stickers, Silver Springs would beat Ferris Bryant in the upcoming gubernatorial race. Superb outreach gimmicks assured travelers that no Florida vacation was complete until they had visited Silver Springs.

Affable and impassioned, Bill Ray treated his publicity department as a team. He respected and prized each of its staff members, who often referred to their colleagues as "family." He nurtured a spirited workplace. John Raym, the assistant retail manager at that time, recalls, "We were like a family. It was so much fun that I used to come in on my days off."

Bill believed in publicity over advertising: "Anybody could plunk down money and buy space. The challenge was getting it for free." At one point he considered turning loose some turtles whose shells bore the inscription SEE SILVER SPRINGS at Weeki Wachee, a competitive tourist attraction on Florida's west coast. Throughout the park, "picture spots" served both the publicity needs and the photo-taking desires of the visitors. Title boards bearing the slogan FILMED AT FLORIDA'S SILVER SPRINGS were placed atop two-inch pipes. These boards could turn 360 degrees so that photographers could title their pictures while capturing an image in the best light and background. This early attempt at branding worked; free publicity was carried far and wide by tourists. In the meantime, Dick Pope, of nearby Cypress Gardens, was getting a lot of exposure for his water ski shows. "I wanted to get more publicity than he did, and I did," Bill proudly proclaimed.

Central to this superb marketing team was photographer Bruce Mozert. For more than forty-two years, he was responsible for the countless pictures used in the pub-

Placing a Silver Springs bumper sticker on a Greyhound Bus. Bill Ray points out, "Tour bus drivers were selected for the ability to make friends and make passengers happy." They were treated to meals and their families were given passes for the rides and shows. Ray adds, "In short, they were treated like royalty at the Springs and they liked it. They were influential in having passengers come to the Springs."

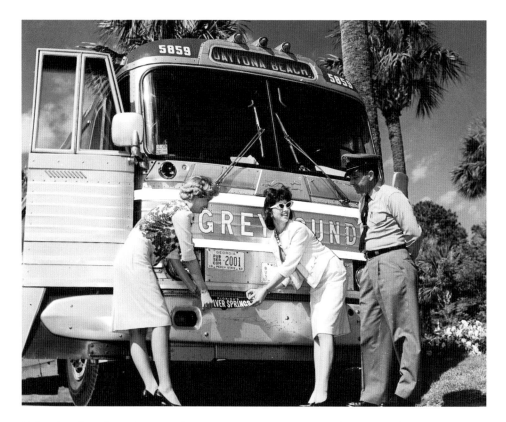

licity that lured tourists to Silver Springs. Not surprisingly, Mozert's successful work coincided with Bill Ray's tenure. To what degree this success was a product of this alliance or Mozert's original publicity stills is not measurable, although it was likely synergistic.

Generally, promotional images at this time ran the gamut from countless grip-and-grin pictures to mind-boggling images. Publicists back then often staged scenes to be photographed long before directorial imagery was in vogue. Bruce Mozert took this genre underwater. A relentless artist, he staged shots where pretty girls tantalized the "audience" while performing mundane activities.

Robert Bruce Mozert was born on November 24, 1916, in Newark, Ohio, the youngest of Fred and Jessie Mozert's three children and their only son. Bruce's sister Marcia was a hand model for Pond's Cold Cream until her marriage. Zoë became a world renowned pinup artist. At one point, the family moved to Scranton, Pennsylvania, where Fred became superintendent of the Scranton Stove Works. After high school Bruce drove a truck, but quickly tired of hauling coal to New Jersey. "I was too sensitive to be a truck driver," he says. Well on her way to stardom in the art world in New York City, Zoë introduced her brother to *Life* magazine photographer Victor de Palma, who hired Bruce as his assistant for three dollars a week. To make ends meet, Bruce cleaned Zoë's apartment in exchange for room and board. Although this was a humble start in a profession, it was time well spent because Bruce became hooked on what was to be his livelihood. "I took to photography like a duck takes to water," he later said.

Mozert worked for the popular magazine *Pic*, getting jobs along the way through his membership in the Freelance Photographers Guild. In 1938, with the family on vacation, Bruce set off for Miami on an assignment to photograph I. Miller Shoes as part of a picture story about women's fashion accessories. But en route Bruce stopped at the chamber of commerce in St. Augustine, where he learned that Johnny Weissmuller was filming a Tarzan movie at Silver Springs. He forsook the shoe shoot and went immediately to Silver Springs because he had already photographed "women walking across brick streets, getting off the Fifth Avenue bus, and getting out of a Lincoln convertible." Public relations officer Wilton Martin gave the eager-eyed photographer a job. After that, Bruce never left Silver Springs, except for occasional related freelance work and a stint in the air force, where he earned his pilot's license and learned aerial photography.

During his first year at Silver Springs, Mozert was introduced to the new world of underwater theatrics and the unique field of underwater photography. He watched as the Hollywood cameraman on the Tarzan set entered a "round jar" that was sus-

pended from an old boat into the water to film the action. One day, as he was observing the jar being used by a cinematographer, Mozert was inspired to design and build a submersible camera casing of sheet metal. He affixed an inner tube on the top of this casing, into which he could extend his arm to advance the film and take pictures. Mozert framed his shots through two nails soldered on the casing's side that were aligned to serve as a viewfinder, while approximating the focus. The photographer could now dive with his camera to find fresh, responsive vantage points. If the results were imperfect compositions, Mozert cropped the images in the darkroom.

Mozert headed for military service in 1939. In 1942, Carl Ray invited him to work at Silver Springs as an independent contractor. Mozert gladly returned to the area with nothing but the motorcycle that got him there, having lost all of his clothes along the way. He met his first wife, Elizabeth, on Ocala's downtown square at Bennett's Drug Store. "She was sitting with an old girlfriend of mine," he recalls. The couple soon married and would have three sons, Wendell Bruce, Robert Bruce Jr., and Allen Scott, each five years apart.

From his workplace at the park, Mozert sold cameras and film when he wasn't photographing every glass bottom boat full of tourists as it was about to pull away from the dock. Back then twelve boats operated simultaneously, with 150-foot double lines of people waiting to board. Mozert had a display stand in one of the park's souvenir stores from which people bought the images of themselves that he had photographed forty-five minutes earlier. He sold these black-and-white prints for one dollar each in colorful folders that had cutout windows and a cartoonlike rendering of a boat. He kept track of the photos that were purchased by counting the number of folders that he had to order, usually 50,000 a year.

Mozert's pictures were so popular that the shop was always crowded with people hovering around his wares. Because the trinket sales were disrupted by these visitors who wanted Mozert's photos, Ray and Davidson eventually built a separate concession stand for him. While operating from that shop from 1946 to 1972, Kodak

Bruce Mozert at work. An assistant holds the underwater lights that Bruce made. Bruce preferred to shoot in subdued light to avoid "the ripples that looked like zebra stripes" in his photographs. This was facilitated by working under slightly overcast skies, during the late afternoons, or deeper in the water. But it was certainly not accomplished with electronic "hot lights" and strobes. Direct flash would "flatten the people out" and darken the backgrounds, so he devised multiple lighting patterns that included scrims and reflectors. His intricate system achieved a natural, albeit sometimes startling, "underwater quality" by allowing "the purity of the springs to enrich the colors and tones."

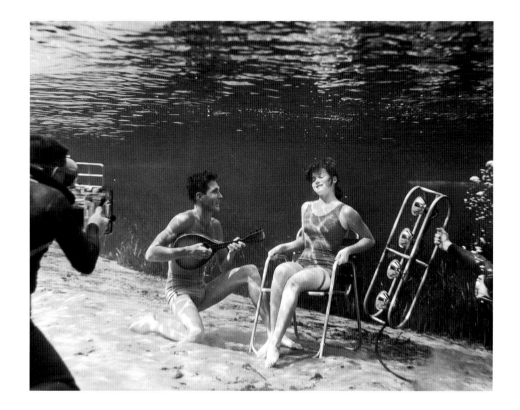

once informed Mozert that Silver Springs sold more film than any other Florida attraction. Many of the publicity pictures that Mozert had shot were of people taking pictures at Silver Springs, encouraging tourists to bring their cameras here.

In addition to selling the lucrative tourist photos, Mozert also accepted freelance work from businesses that Silver Springs had attracted. These clients paid a dollar and a half for each of their prints, the same amount that he charged Silver Springs for their publicity stills. By now, Mozert had become a successful photographer-entrepreneur with a six-figure annual income.

When Bill Ray came to work at Silver Springs, new commercial accounts began

to supplement the income that was derived from the concessions. Silver Springs was paid by other businesses that were creating their own advertising photos on its property. Management could loan or rent all of the needed equipment to visiting film crews. If Silver Springs was credited in the finished photos, motorboats, bathing suits, masks, fins, and scuba tanks were free for the asking. The scuba tanks, manufactured by a contracted corporate client, bore SILVER SPRINGS stenciled in black block letters along the shiny cylinders. Because visitors could photograph the professionals using these tanks, free publicity often appeared in the snapshots and 8mm movies that they took home. And since professional photographers and motion picture cameramen were drawn to Silver Springs, people reading magazines and watching movie theater newsreels were treated to the delightful scenes recorded there.

The audiences grew under Bill Ray's watch, during which time an increasing number of national magazine covers and ads were displaying Mozert's pictures. All the while, Mozert's own ideas continued to evolve, both imaginatively and technically. He designed underwater lighting gear to accentuate a subject or to freeze motion. His strobe light, synchronized with a fast shutter, was powerful enough to "stop" a boat propeller going sixty miles per hour. Mozert believes that he shot the first underwater color photographs to be used in *Life* and other national magazines.

Mozert's passions kept him in the water where his creativity ran wild. His camera was a compliant accomplice, making and recording history in the service of promoting Silver Springs. But his single-mindedness required willing cohorts. Ginger Stanley was an accessory to the fact and the fictions that he created. Ginger was trained to be a Weeki Wachee mermaid by underwater shows pioneer Newt Perry. The eighteen-year-old beauty contest winner came to work at Silver Springs in 1953, where she was the primary model and swimmer in Mozert's photographs. There were often others in the pictures, usually local people or other employees who performed as background extras. Almost everyone working at Silver Springs juggled several responsibilities, and Ginger was no exception. She also worked in public

relations. Upon leaving the attraction after three and a half years to marry, she said, "It's going to take three people to replace me—one to run the front desk, one to lead VIP tours, and one to pose for pictures." Indeed, when Ginger wasn't being a hostess or posing for Mozert, she was sending out the press releases in which she was the pictured model.

Mozert showcased the real star of Silver Springs, the water, while directing the swimming models. His imagery was based either on dramatic scenes or classic beauty. The young women were captured on film underwater while practicing swan-like ballet techniques or performing activities that burlesqued everyday life on land. The models had to appear natural; even their smiles had to look unforced. But it wasn't easy for the girls to follow Mozert's instructions while underwater. With elaborately staged activities, Mozert's sensibilities were somewhere between *The Three Stooges* and *Leave It to Beaver*. This was Florida vaudeville, shtick for the camera and for mass consumption.

Dick Ritchie, who was the shop foreman and the supervisor of the building of the glass bottom boats until the late 1950s, meanwhile had improved the underwater jar by converting it to a "photo sub," a partially submerged, windowed compartment. Two photo subs were constructed and attached beneath two boats. One sub was large enough to hold a small party of visitors while the other was designed to carry one or two professional photographers. It was made available to the pros without charge if Silver Springs received credit, while a ticket for a glass bottom boat ride included a ride in the photo sub designed for visitors. While in the sub, Mozert would angle the attached sheet glass to facilitate his photographing; he now could be under the surface of the water, eye-to-eye with the swimmers. Nevertheless, once he became a seasoned scuba diver, Mozert preferred to wear scuba gear because he could more freely access his desired vantage points. Using Plexiglas, he further improved his underwater camera housings. Adding external shutter releases allowed him even more flexibility.

People looking through the port-holes of a photo sub boat. Note the "picture-taking picture" that was a favorite marketing ploy to entice visitors. They "encouraged visitors to bring cameras and make pictures. When they were home and showed the pictures of Florida's Silver Springs they gave us the kind of promotion that you couldn't buy," exclaims Bill Ray.

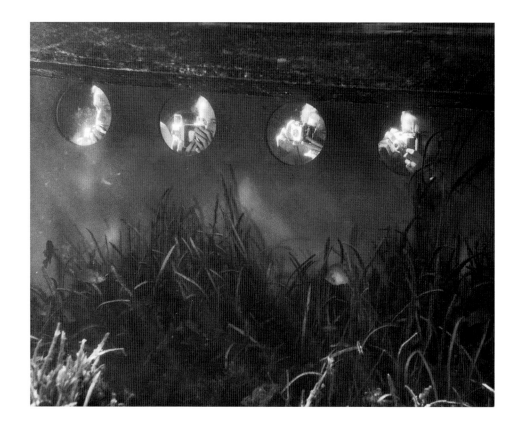

A production was a group effort with Mozert as the team captain. "He'd used to get so enthused, you'd get enthused, too," remembers Ginger Stanley. Mozert's creative juices were always flowing while he was dreaming up what to do next. "This will be fun," he would excitedly announce. He had an idea to enact an underwater circus with a snake charmer. For this photograph Ginger had to kiss a harmless indigo snake. A circus would sell drinks and snacks, so a striped concession stand was built as a backdrop for the other models who were sipping from soda bottles and eating hot dogs.

"Bruce was energetic, a genius," says Bill Ray. "He was the most single-minded photographer I ever knew. He was the most diverse friend I ever had. Bruce was easy to get along with. I can't think of anybody he didn't get along with." Mozert, of course, was extremely happy with his duties, with his coworkers, and with his boss. He says, "We couldn't wait to come to work."

Mozert's cast was eager to perform effectively, but it was difficult work. Unaided underwater swimming was an art that required intricately controlled breathing techniques. The swimmers were taught to hyperventilate by first completely exhaling. Next, they would breathe in deeply several times in a row before diving, and then they would control their depths by exhaling. This "underwater elevator" technique would take the swimmers to the bottom, where the staged shots were taken. Sometimes Bruce would weigh them down or encourage them to lock an ankle around a prop to allow him enough time to take pictures.

Ginger explains, "Bruce's mind would be so far ahead of what he was doing. He'd be so far ahead of everybody else. It was hard but fun. Bruce was a super nice guy. He'd already be laughing about the end result. We couldn't envision it. His creative thinking was beyond what his speech was able to tell us. He got the joke before we did. Bruce thought of it, made it, or got the props together to make it." Ingenuity often saved a shot; Mozert would always discover a way to make things work. Tiny weights held hula skirts down so that they would sway with the dancer's body. A deck of oversized playing cards was shellacked to keep them upright while the gamblers assessed the hands that they had been dealt. Each scenario posed its own problems, but Mozert joyously solved them.

Upon improving his original underwater camera housing, Mozert was then able to use it for both still and motion picture cameras. Movie making had come to Silver Springs in 1916 with the shooting of the silent production of *The Seven Swans*, starring Richard Barthelmess and Marguerite Clark. In 1932, the same year that the gasoline motors of the glass bottom boats were converted to electric motors, the produc-

Silver Springs's public relations staff members Ricou Browning and Ginger Stanley filming *Revenge of the Creature*, at Silver Springs, which followed *The Creature from The Black Lagoon*. Browning played the Gill Man in the underwater scenes in all three of the films (*The Creature Walks Among Us* was the final installation) and Ginger swam for stars Lori Nelson and Julia Adams in *The Creature from the Black Lagoon*.

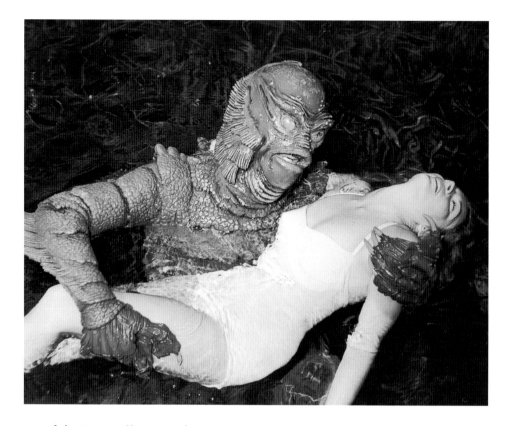

ers of the Tarzan films came here, attracted by the exotic surroundings of the park. Between 1932 and 1942, Johnny Weissmuller and Maureen O'Sullivan performed here in six of the original Tarzan movies, thus firmly establishing the place as a movie-making locale. In 1955, four features were shot here.

Occasionally Mozert was hired to film movies, but usually he shot the stills for the promotions of movies, such as the 1946 release of *The Yearling*, starring Gregory Peck and Jane Wyman. He likewise photographed Lloyd Bridges while he was acting in the 155 episodes of television's *Sea Hunt*, which was filmed at Silver Springs between 1958 and 1961.

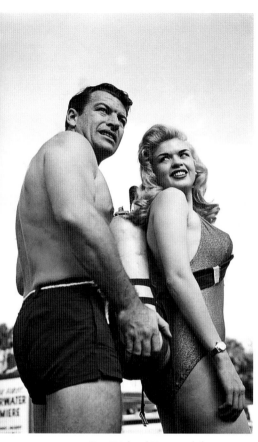

Star Richard Egan and then-unknown Jayne Mansfield at Silver Springs for the 1955 premiere of Howard Hughes's *Underwater*. Two hundred guests arrived by plane from New York City and Los Angeles.

Howard Hughes's film *Underwater*, though filmed in the Caribbean, premiered at Silver Springs. While hydrophone speakers provided the sound, the film was shown *underwater* because the water here was clear enough to allow projection onto a submerged screen. Burrell's Clipping Service, which Silver Springs had employed to assess the effectiveness of its public relations department, reported that some seven hundred newspapers and magazines ran stories about this debut. At one point, Jayne Mansfield, then an unknown aspiring actress, arrived uninvited to swim in a bathing suit that became translucent when wet. She got a Hollywood contract from this stunt, but not from Hughes.

Mozert directed underwater "short subject" movies and still photo sequences. These films would precede feature presentations in theaters, along with cartoons and newsreels. Movie companies often initiated the shorts to allow winter junkets for their producers. These moviemakers might come in November to create a feature about Thanksgiving dinner. Mozert would dream up the scenario; he would have the turkey prepared and the dinner table set. Then he would direct the skit as he photographed. These slapstick sequences included boxing matches, picnics, and even a girl awakening in bed. As Ginger says, "It's better underwater."

Silver Springs spent more on advertising than the other leading Florida attractions combined, about $500,000 a year during most of the 1950s. Because of that advertising and because of Mozert's 8 x 10-inch glossies that appeared in many newspapers and magazines, people came in droves. Mozert's pictures brought a human and humorous touch to life beneath the water's surface. In 1950, some 800,000 visitors came to Silver Springs to enjoy its natural wonders.

The glass bottom boat guides enchanted their audiences as they pointed out the approaching Mammoth Wall's 17- to 31-foot drop, the Big Springs, and the Endless Cavern from which more than half a million gallons of water flow daily. From the Reception Hall, where "spectral rays scintillated upon the limestone walls," to the Bridal Chamber from which a flimsy veil of shell is constantly emitted, to the

One of the many publicity stills generated by Silver Springs. Both cut-lines and pictures were designed to allure people to the park. Note that Bruce used half-inch borders, whereas the standard was a quarter inch, to distinguish his work from others.

Ladies Parlor of Rainbows, which was mirrored against pink alabaster walls, and to the Devil's Kitchen, where bubbling charcoal looks like smoldering flames—all were equally awesome. Guides might alert passengers to the prehistoric bones, petrified cypress logs, and even a sunken boat that legend said was from Hernando de Soto's devastating march through Florida. Delighted visitors might be shown set remnants from the movie *The Blue Grotto*, "where the ethereal blue water is clearer than the air you breathe," or the Decorated Christmas Trees or the Turtle Meadow where schools of fish parade. Tourists would see the Garden of Eden filled with coral and silk ferns of many colors, or the Sunken Gardens, where they learned that

it contained "the most interesting sub-aquatic plants on display anywhere, actually resembling forests viewed from an airplane." Indeed, looking through the glass, passengers seemingly floated. Because of the water's transparency, objects appeared to be suspended in air.

Once the dust from World War II had settled, Florida's growth was certain because many discharged servicemen returned with their young families to the state in which they had been stationed; some came to vacation, and some came to put down roots. Those who were vacationing knew about Silver Springs being family-oriented, but they also were drawn by Mozert's pictures of those beautiful girls underwater. However, because management adamantly had maintained and enforced family values, swimsuit straps were always kept up on shoulders; Mozert never shot downward on a model's breasts. In fact, should one of Mozert's print images prove to be too revealing, the negative would be destroyed. The success of the park depended on Bible Belt modesty, after all. In Mozert's terms, the girls were performers whose sexuality was alluring because they bared nothing but a teasingly good form as they were caught "unaware" by the camera.

While Mozert may have learned the art of representational female allure from his sister Zoë, he undoubtedly was influenced by the times in which he was creating these photographs. Pinup artistry abounded everywhere, especially during the war years. Bill Ray acknowledges, "All the great artists did sexy pictures of girls, what we thought were sexy in the forties. Water made a girl look as good as she's ever going to look; they looked better and prettier. The girls were motivating magnets in bringing people here." In addition, "the water made a halo out of their hair," almost making them appear to be heaven-sent. "Can you think of anything else that would so effortlessly demonstrate the clarity of the water?" asked Bill. Certainly pictures featuring fish, turtles, or otters would not have had the same impact.

Mozert was well aware of a simple, time-tested formula for success in publicity: men love to look at pretty girls. He also knew how to maximize a girl's physical ap-

peal by having her wear high heels or stand on her toes. Posed in this manner, the muscles in her legs and torso would tighten, accentuating her figure. His pictures were advertisements for Silver Springs—nothing more, nothing less. Mozert's job was to promote Silver Springs. He did this by using his "angels." The girls "were so beautiful, and I treated them as works of art," he recalls.

Bill Ray asked Betty Frazee, a high school drum majorette in nearby Reddick, to become a swimmer-model. After graduation she accepted a secretarial job at Silver Springs, signing a model's release at the same time. She went on to become the primary subject of Mozert's pictures from 1957 until 1959, when she married. "Bruce was always making me jump," Betty remembers. "Fun and vitality showed through the photos, as well as showing off the spectacular natural beauty of Silver Springs." Mozert wanted to portray Silver Springs as the wholesome outdoor place that it is. These beautiful girls personified this characteristic. As Mozert says, "Everything has a picture in it, a sellable picture. All you got to do is use your imagination." He surely used his, thinking up all sorts of ideas that sold because his creations were perfectly calibrated for his time, place, and audience. Viewers gladly suspended their disbelief.

The models could not wear scuba equipment because doing so would destroy the veracity of his images, and sometimes Mozert couldn't either. He once rigged a funnel with a hose that redirected the exhausted air from his own scuba tank during a commercial shoot for Johnson Motors. Mozert did not want the escaping bubbles to distract from his main focus, a water skier who he was photographing from below. He didn't allow air hoses in the scenes, so any that were used for the deeper shots were pulled away and returned as soon as the pictures were snapped. Mozert preferred that his models be nonsmokers or light smokers, with good smiles. "The girls were trained topside to hold their breath for at least two minutes. They would come up for air and go back down. We would shoot the same scene several times over. Before we would train a girl, we would make sure she was not a chain smoker.

A promotional photograph. Typically, one of Silver Springs's boats was strategically positioned in the background.

Women who smoked heavily couldn't hold their breath underwater for more than thirty seconds."

Mozert had no competition. No one else was creating pictures as zany as his. Underwater, a woman cooks on an old stove while putting a wooden spoon to her mouth to sample the fare. Condensed canned milk floated through holes cut in the top of a can, looking just like rising smoke. While being suspended in the water, a woman wearing a witch's hat appears to be flying on a broomstick. A model standing next to a submerged newsstand shows off a *Post* magazine bearing the banner "Eisenhower Elected." Neptune's secretary sits on the King of the Sea's lap while taking dictation. A model reads a book underwater while wearing large, gaudy sunglasses. Another bathes in a tub while scrubbing her toes. One woman reclines on a chaise lounge as her beau peers through a window in which an air-conditioning unit is humming away.

The list of Mozert's creations is almost endless. A woman pets a fish, one that actually had to be held out of the water long enough to be too weak to swim away. Another model sits in an oversized fishing hook as bait, alluring an approaching fish. An archer's arrow is frozen as it flies through the water, just before hitting its target. Claiming that his forte was anticipation, Mozert knew the distance that the archer needed so that the arrow would go straight on course before ascending due to buoyancy.

Mozert also took effective promotional pictures on land. They were usually classically composed scenes of people gazing out at the glass bottom boats, framed by the beautiful foliage surrounding the springs. A young woman clad in a bathing suit was often central to these pictures. The boats were staples in the background, providing a sort of marketing shorthand that was subliminal advertising for the park.

Mozert also shot photographs here for blue chip companies to use in their advertising campaigns. By contractual terms, Mozert was duty-bound to include the logos of these companies in his pictures. In fact, the symbols or names of Mercury

Motors, Coca Cola, Jantzen, Carter Craft, and Voit might all appear strategically placed in a single picture. Bill Ray explains, "When film crews came to the Springs, we would supply boats, diving equipment, and Mercury outboards which would often end up in their productions. At one time we were shooting for thirteen boat companies. Mercury engines were on every boat unless the boat company sent in a boat with another engine. We shot pictures for Jantzen bathing suits, which we used in all shots with bathing suits. So in many pictures with a boat we had the Mercury, the bathing suit, and possibly Voit Rubber Company dive gear. Only the party for whom the picture was made paid. All the others got a benefit, too." All participating companies profited from this scheme, and Mozert was able to "double-dip" by using the pictures that he took for these businesses as publicity shots for Silver Springs.

Mozert and his imagination worked overtime. He photographed monkeys and birds setting clocks' hands, an alligator typing a letter, a squirrel casting a vote in a ballot box or drinking through a straw, and a skunk sniffing one of the many flower beds at Silver Springs. Mostly, though, he produced a never-ending stream of beautiful women doing hokey things underwater. His photographs fascinated people and lured them to the attraction.

For many years, visitors continued to peer with sublime wonderment into the depths of the springs while they were gliding in ever-improving glass bottom boats. But the fascination would not last. Although Silver Springs would survive as an attraction, its disposition changed with modernization. By the late 1950s, the aging hand-built hard cypress glass bottom boats were being replaced by ones molded from fiberglass. Simultaneously, old American mores were being displaced by newly evolving ones. Indeed, the appeal of Silver Springs itself and the fascination with Mozert's photographs began to wane. His most creative years dimmed as the postwar mentality yielded to the new world order that was on the horizon.

The 1960s boiled as well as rocked. Many social customs began to fall or at least weaken. The days of the old ways were numbered. The changing times witnessed an

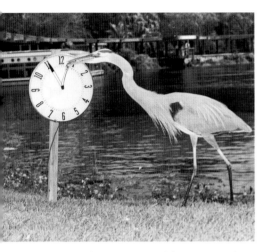

An example of how Bruce could conceive and execute catchy ideas. For this photograph he baited a small piece of fish on the hand of the clock where it could not be seen, but the Great Blue Heron "could smell it."

amazing youth revolution that affected the culture from its moral fibers to its popular art, music, television programming, and fashion. The cultural value changes were seen clearly in the women's liberation movement, the civil rights crusade, anti-war protests, and the liberal arts curricula at universities around the country. Furthermore, commercial air travel, already saving precious time, was becoming increasingly affordable. The world was evolving rapidly into a fast-paced youth-oriented place. Mozert's good, spirited fun was on the precipice.

Automobile travel had been a leading factor in the high yearly attendance at Silver Springs, with its numbers ever increasing as cars became the favorite mode of vacation travel. Ironically, cars also ultimately led to the demise of Silver Springs as a premier attraction. Postwar prosperity made the family vehicle a necessity. A car meant freedom, but leisurely driving now was becoming a thing of the past.

Signed into law in 1956, President Dwight D. Eisenhower's interstate highway system was soon underway, crisscrossing the nation. This system reduced travel times, proved safer than stop-and-go driving, and facilitated economic growth. The first section of the Sunshine State Parkway, Florida's turnpike, opened in January 1957, running from Miami to Fort Pierce, 110 miles north. Upon completion it would ultimately bring drivers to Wildwood, 312 miles northwest of Miami, the same length as the St. Johns River, which delivered visitors to Silver Springs a century earlier. New highways altered how people lived, worked, and played. Americans were on a high-speed course with direct routes between here and there. Ultimately, attendance at Silver Springs began declining with the completion of I-75, placing the flow of traffic further away from highways 441, 301, and 27, which serviced the park.

Riding along country roads became passé. Sunday drives became rarer with the gasoline shortages of the early 1970s. As orange groves and cow pastures began vanishing, the old tourist attractions were suddenly out of the way, no longer on main roads. With the coming of corporate takeovers of some of the aging attractions, the

heyday of the small-scale parks ended. The souvenirs from Silver Springs, along with those of other older tourist destinations, became kitsch. Florida's population during the 1970s soared with newcomers who didn't have any connection to Old Florida. Simultaneously, Florida's old-time tourist attractions began to disappear.

The interstate system factored into bringing Disney World to Orlando. Each interstate exchange was to become a new Main Street with residential "bedroom" communities that included chains of restaurants, motels, and service stations. McDonald's Golden Arches led the charge with sixty-second food service; now travelers were in a hurry. With the opening of Disney World in 1971, all roads suddenly led there. The Magic Kingdom was a giant magnet, drawing in cars. Drivers passed the old-fashioned places and instead headed for the 28,000 self-contained acres of make-believe. Now more people were attracted to the future than to the old symbols of the good life that Florida offered and that Silver Springs epitomized.

In the meantime, the American Broadcasting Company purchased Weeki Wachee, and Wometco Enterprises bought the Seaquarium. Many of the old parks were being retrofitted to compete with Disney, adding wild rides and water thrills in attempts to be relevant. The roadside attractions often were located on prime real estate that their owners sold to developers. Some were squeezed out by encroaching commerce. The big corporations cared about their bottom lines and little else. They were simply "milking it, not motivated for the long-term good," laments Bill Ray.

Silver Springs, however, did persist while adapting as best it could in this super-sized world. In 1962, the American Broadcasting Company bought from Ray and Davidson the four thousand acres that they had owned outright and their lease to the eighty acres around the head of the main spring. Promptly, a general admission charge was installed for the first time. In 1972, Silver Springs was placed on the National Register of Historic Places. In 1973, attempts at modernization began with a Wildlife Rehabilitation Program to care for injured animals. Wild Waters, a water park, opened in 1978 on six acres of the parking lot. Ownership changed

hands several times, ending up with the management of Florida Leisure Acquisition Corporation in 1989. The Jeep Safari, a jungle ride through thirty-five acres, began the next year. The following season saw the start of the Lost River Voyage, showcasing the same "untouched and untamed part of Florida" that intrepid travelers ventured to see more than a century ago. Once "nature" was everywhere, but now it was being sectioned off, developed, and gated. At Silver Springs, seeing the springs became an afterthought, something nostalgic to do between eating and shopping at the mall.

In 1993, the State of Florida bought Silver Springs and oversaw its management. An automobile museum opened there the following year, with the White Elephant Exhibit coming in 1995. Expansion included new rides, shows, exhibits, and restaurants. Management changed hands several more times through 2002, when Palace Entertainment of Florida took over. Now the arcade of shops looks different, having been burned and razed more than once. No one is there now to take snapshots of eager visitors sitting in the glass bottom boats. The patrons are older, many coming often with their annual passes. Revenues are now enhanced through a concert series featuring fading big-name entertainers, outdoor events like the Native American Festival, and various arts and crafts fairs. Fewer people have the time or the interest to listen to the guides, who still offer magical, mystical tours around Silver Springs. Attention to the springs is secondary, at best, in this postmodern world where experience, like entertainment, is simulated, spectacled, and even virtual. Meanwhile, as one thousand people a day move to Florida, Silver Springs slips further and further into the collective memories of the Sunshine State's residents.

Gary Monroe

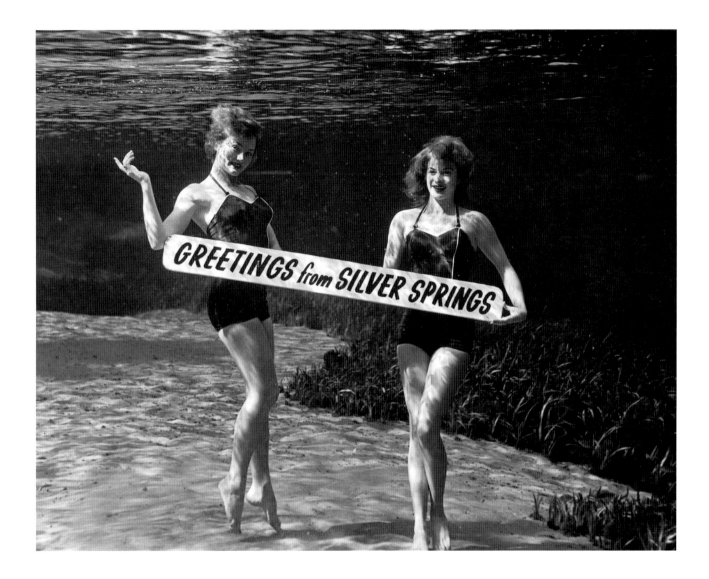

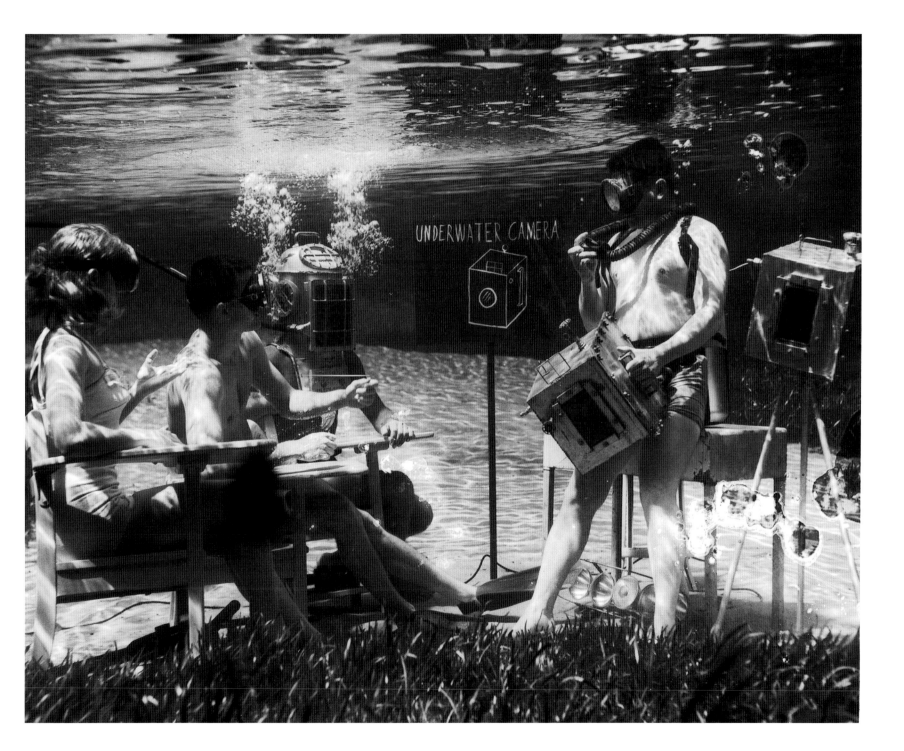

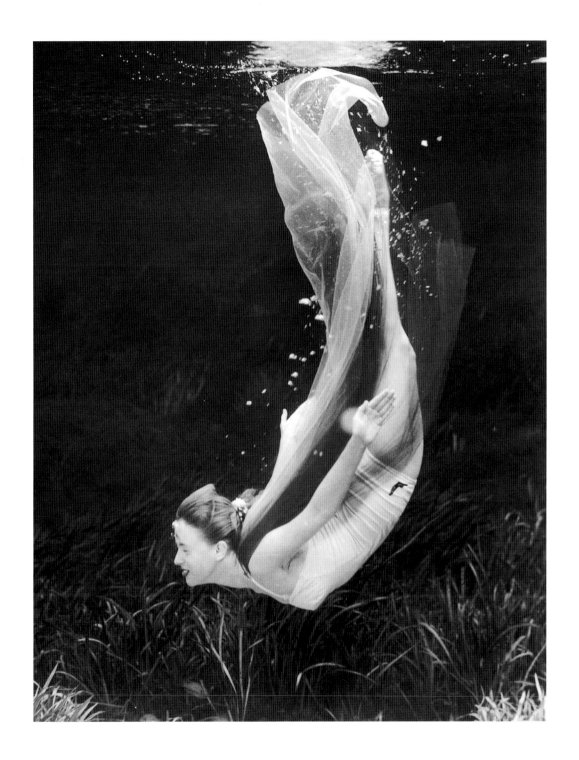

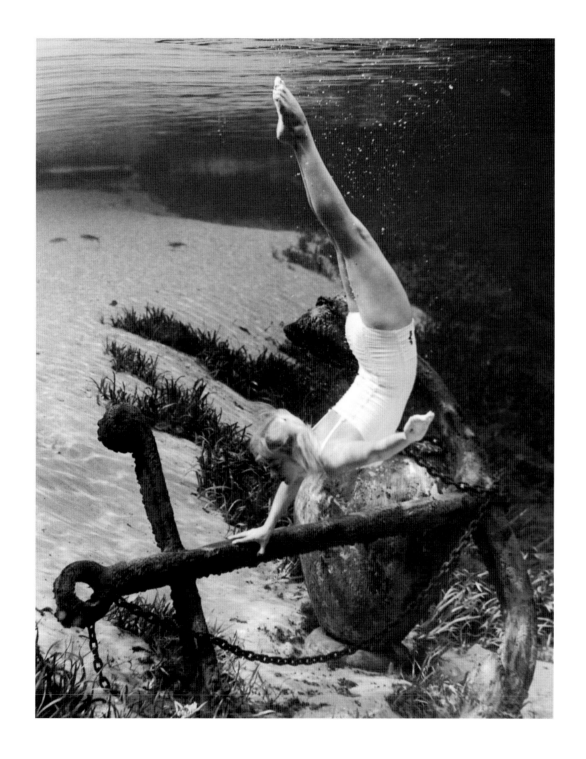

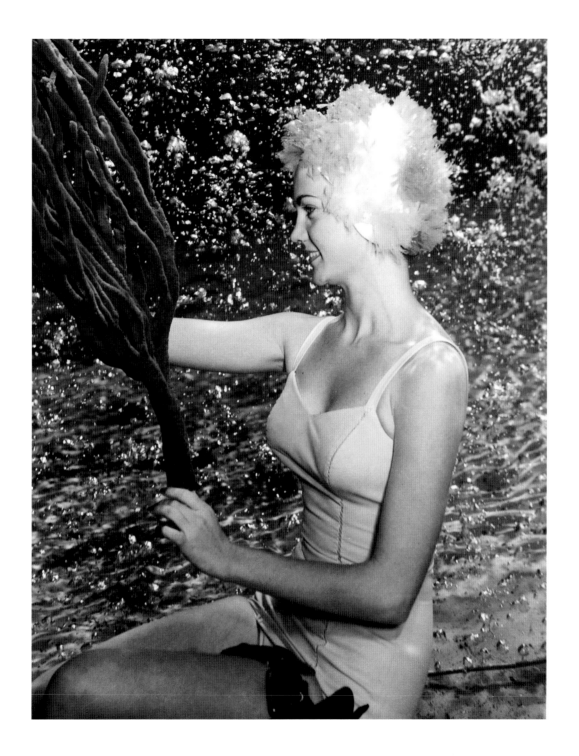

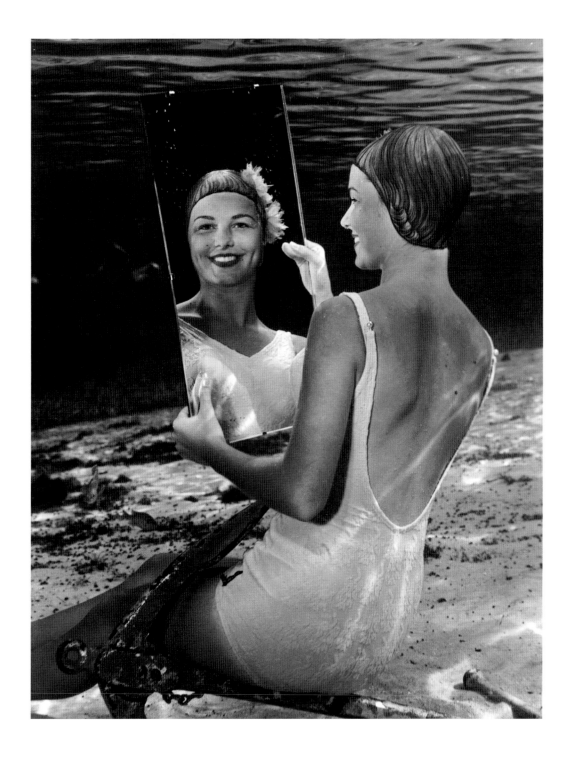

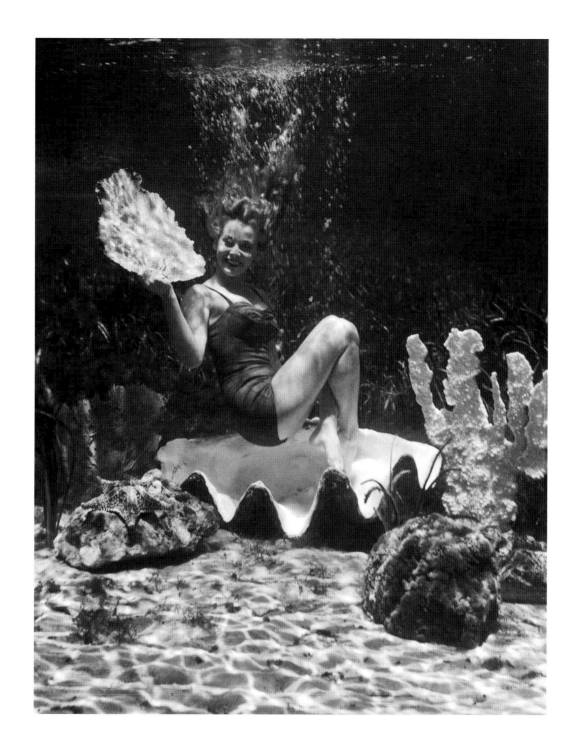

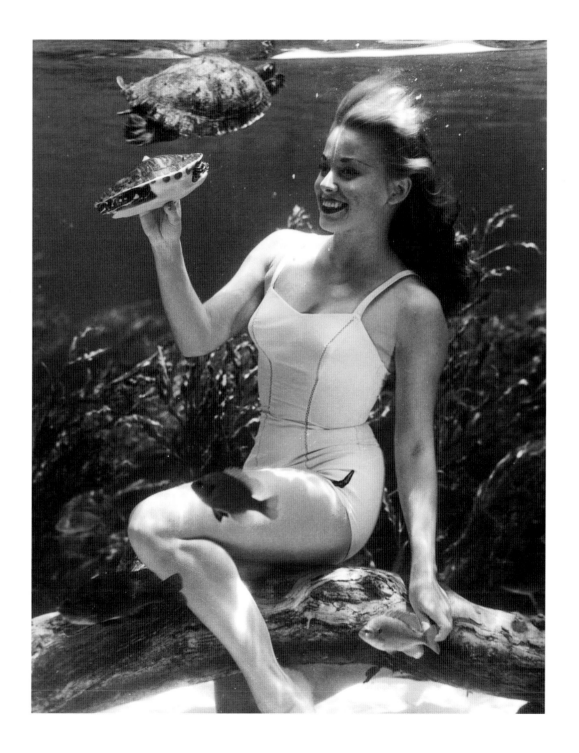

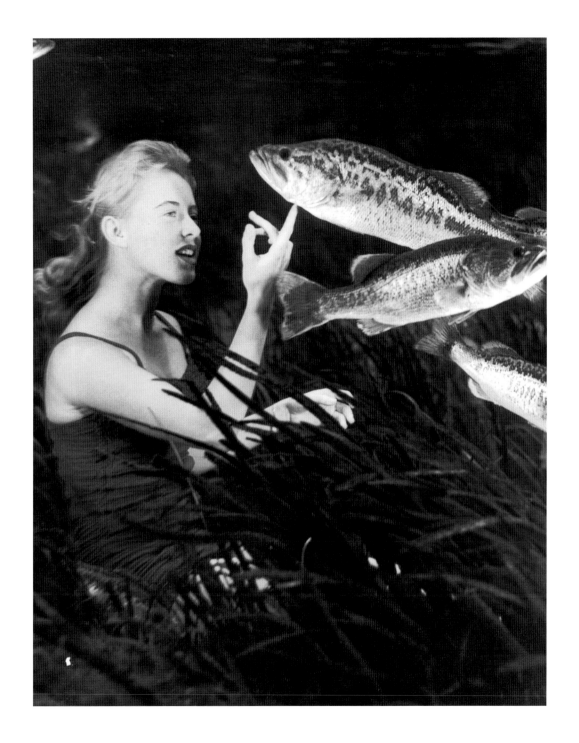

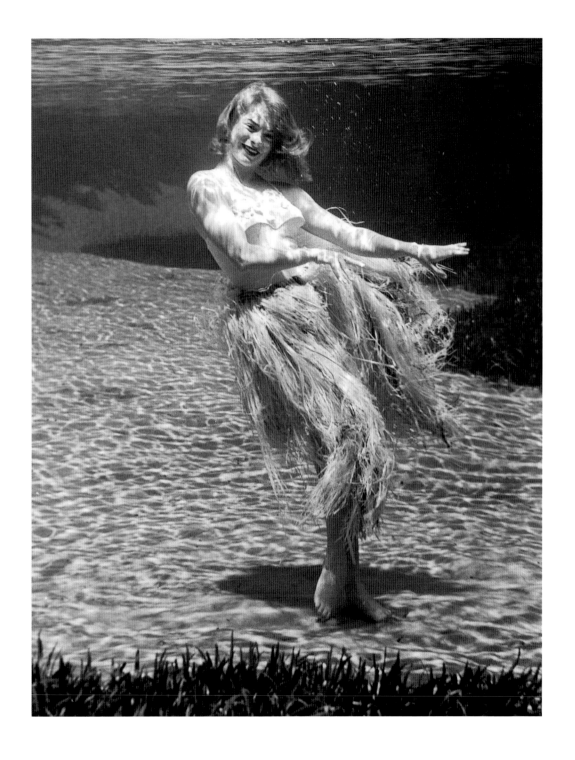

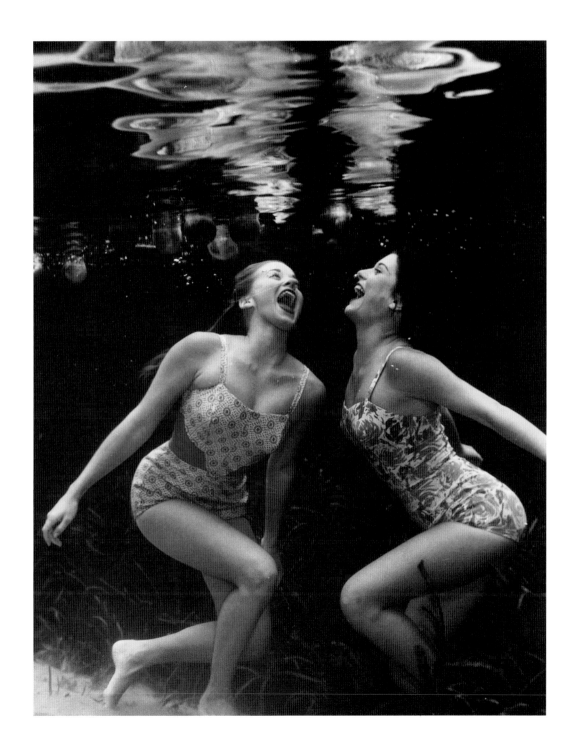

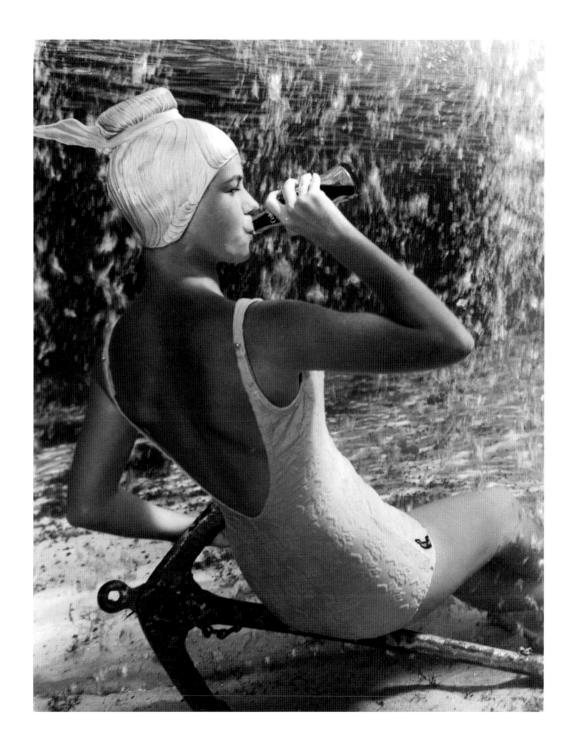

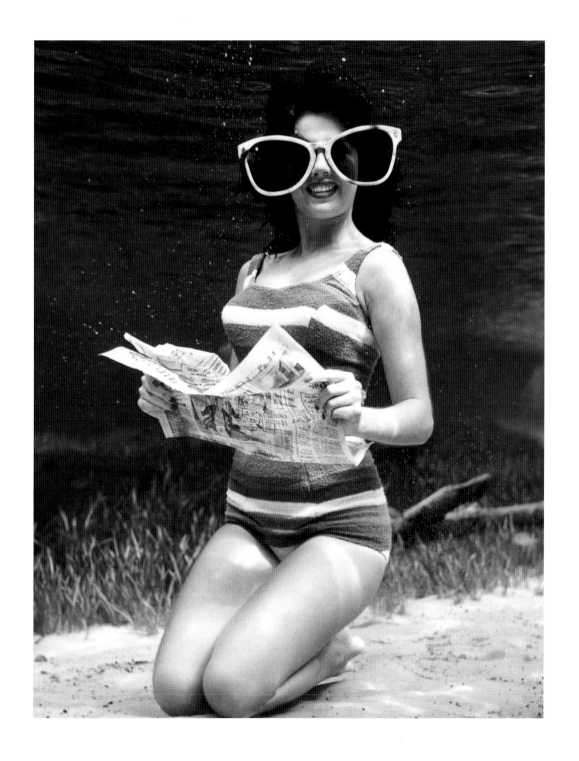

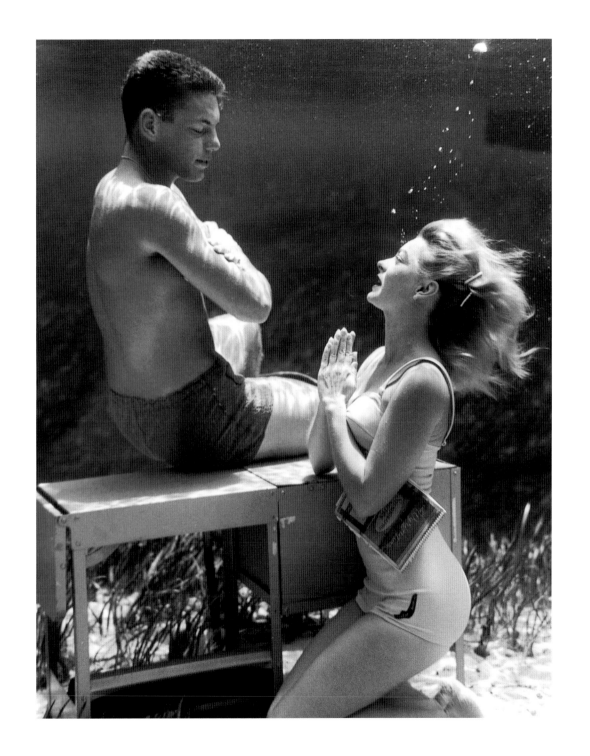

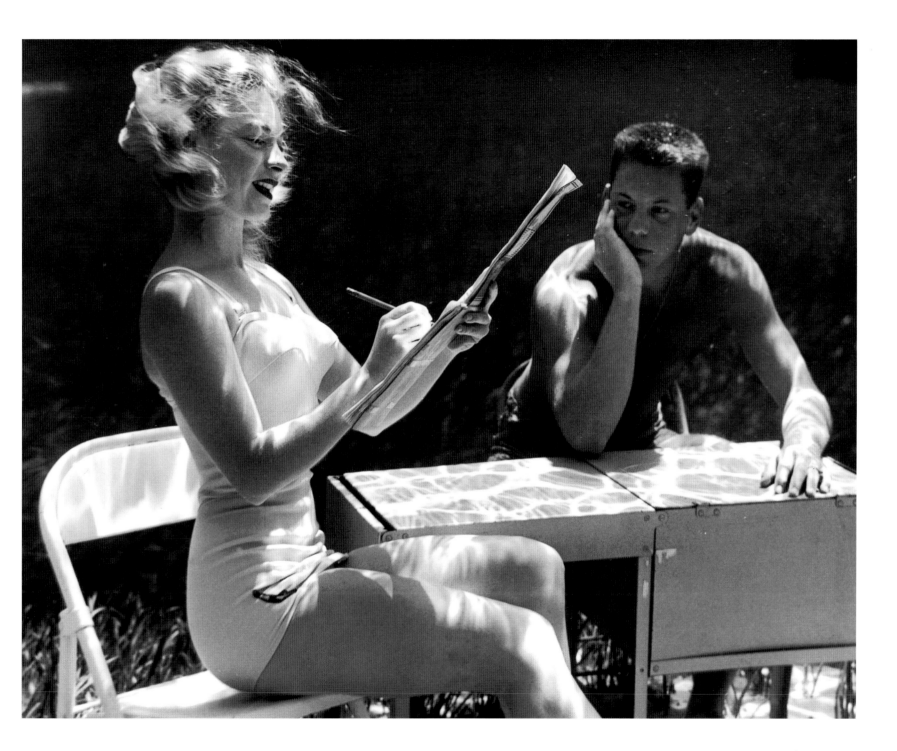

74

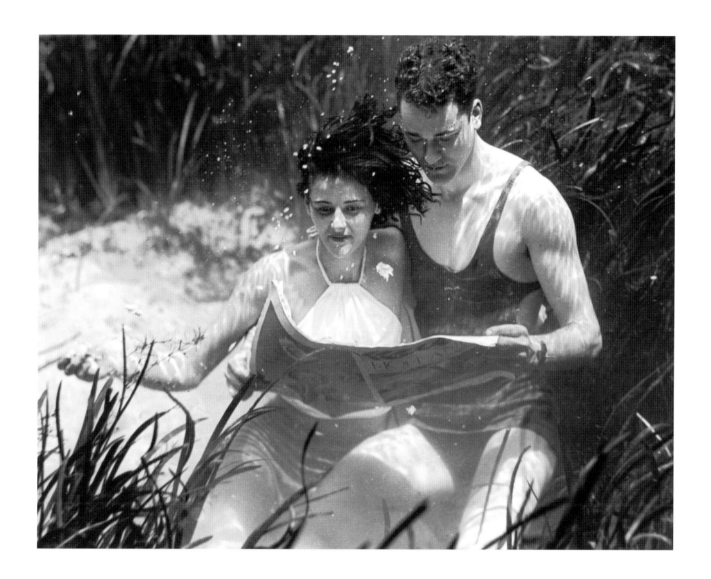

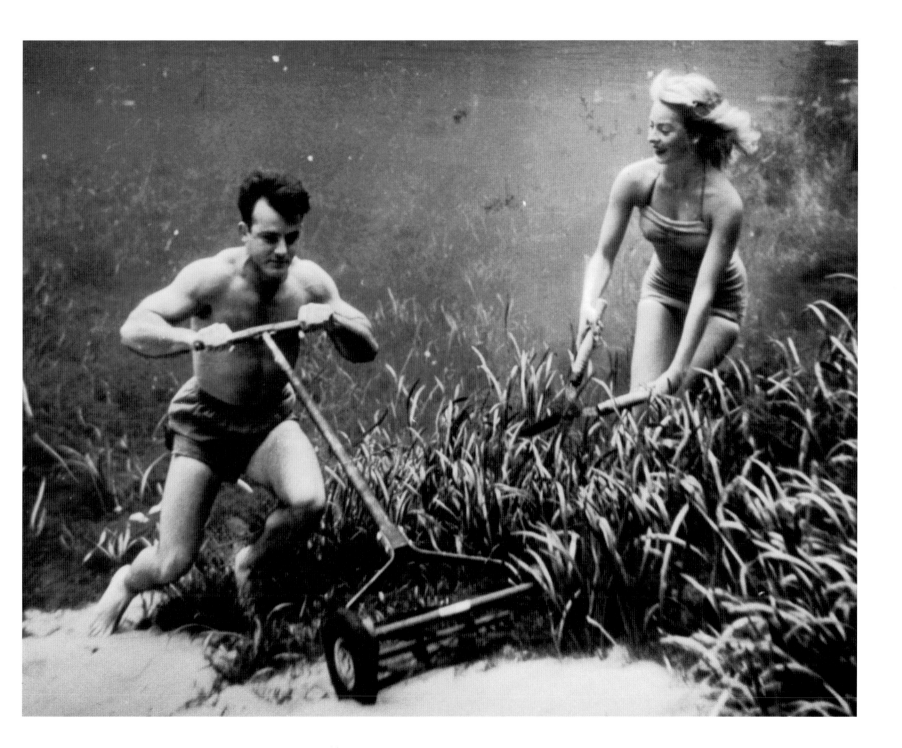

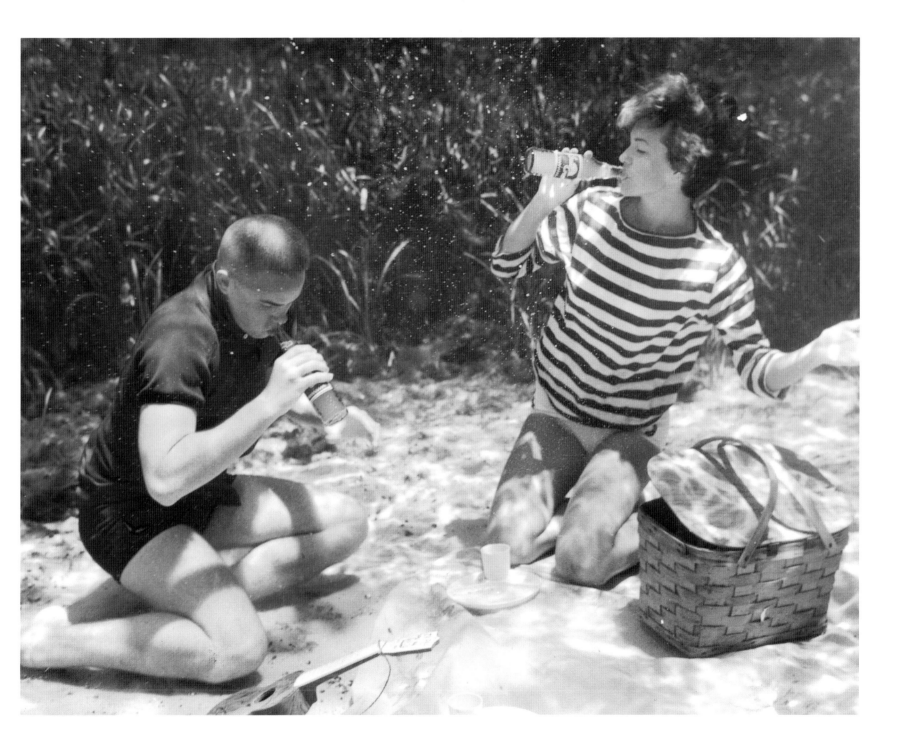

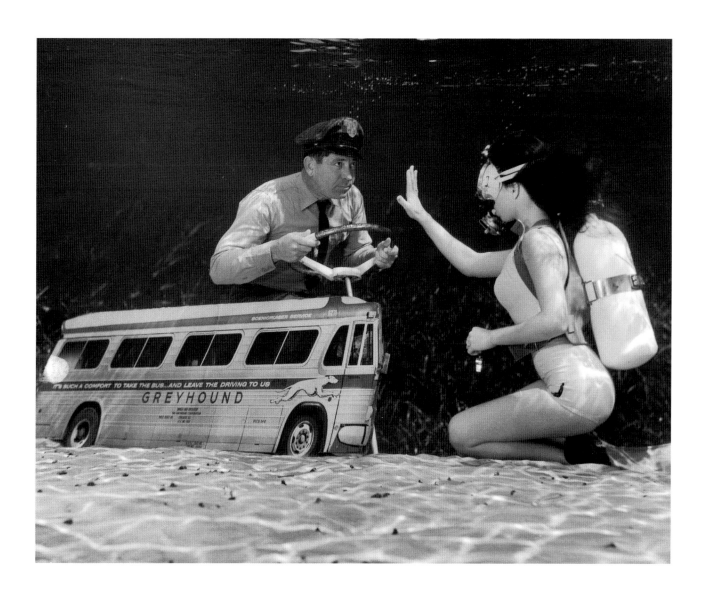

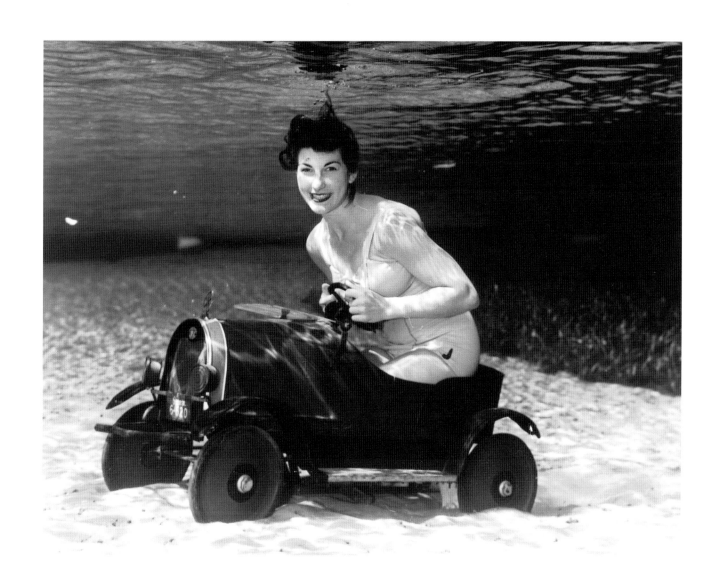

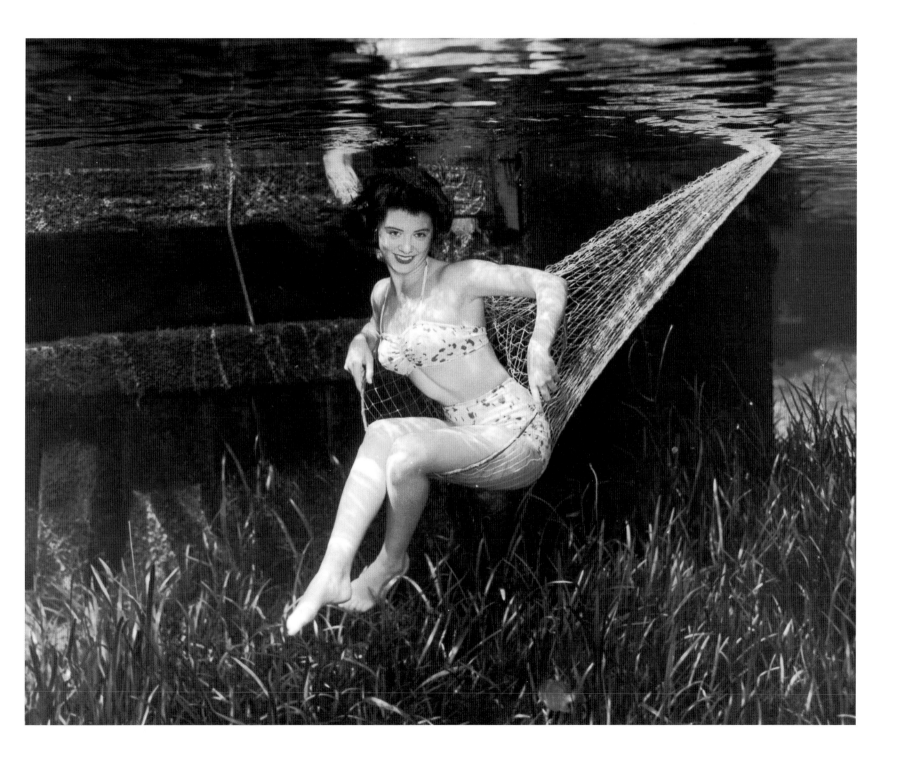

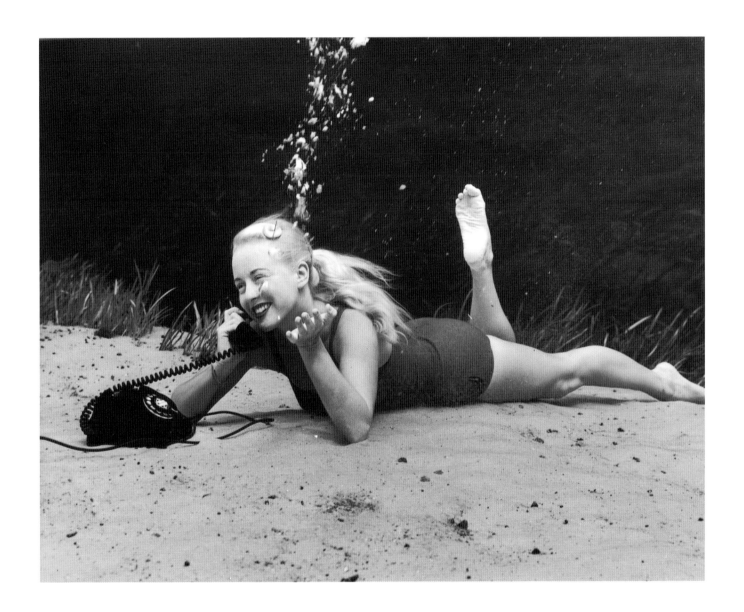

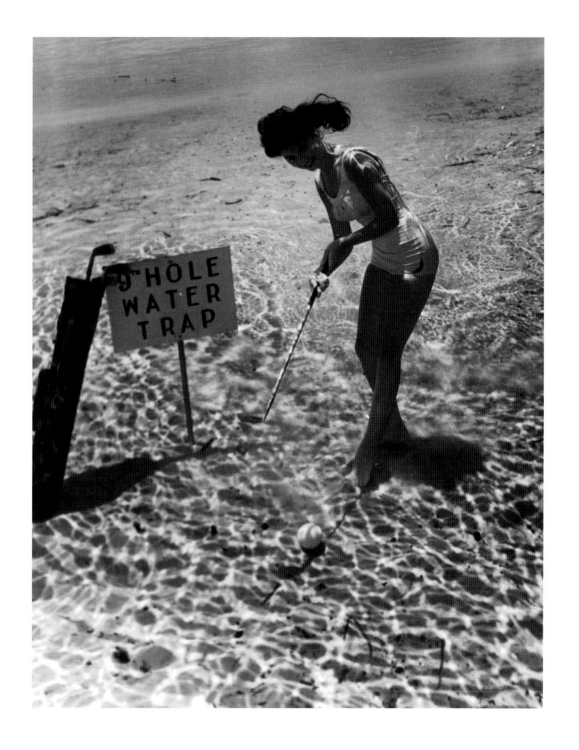

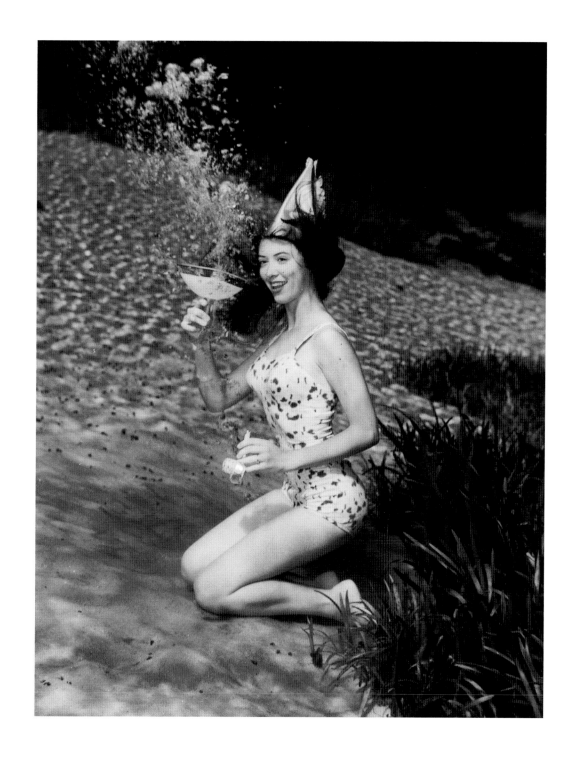

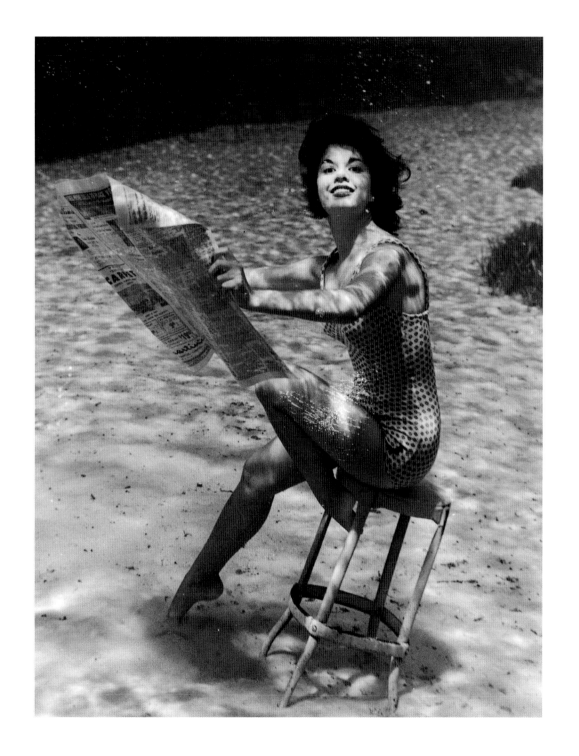

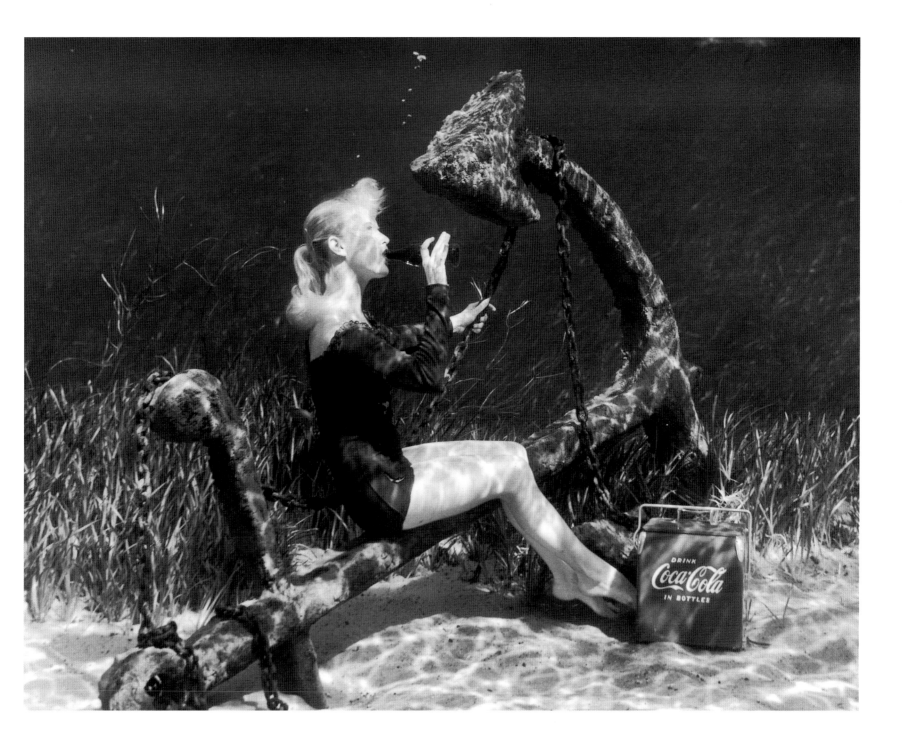

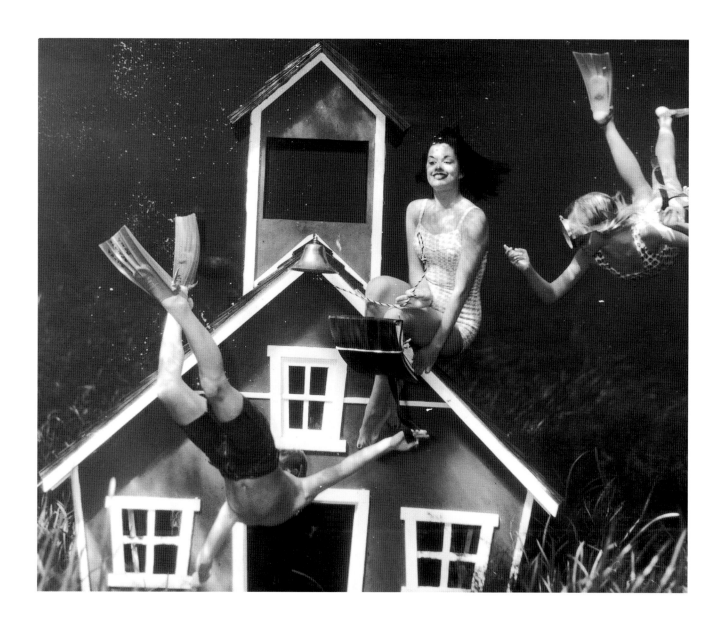

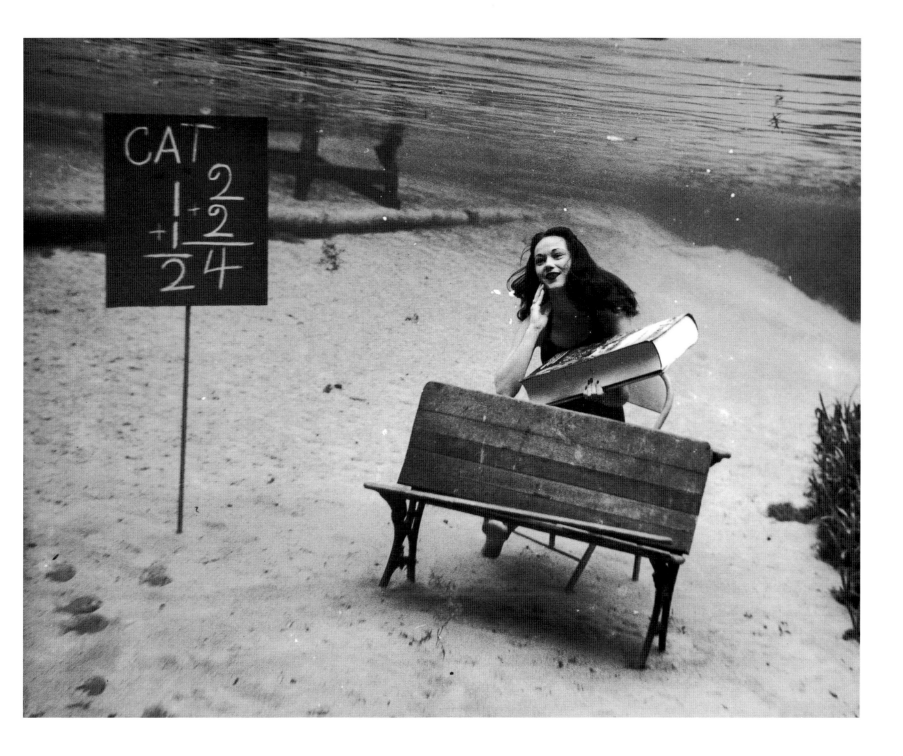

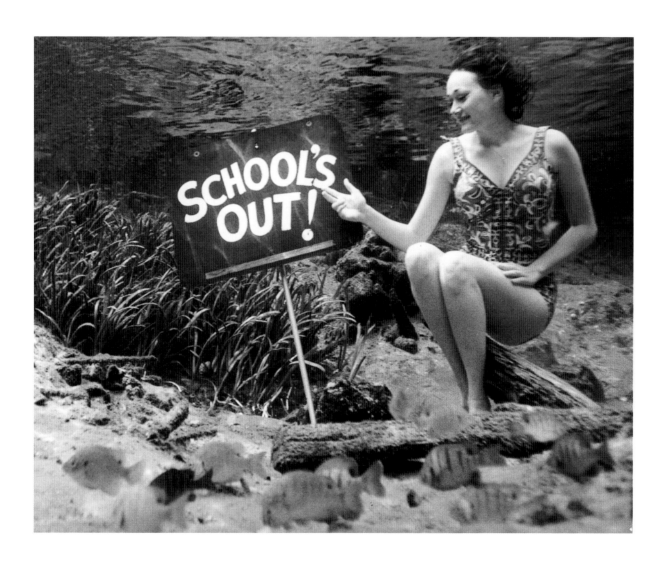

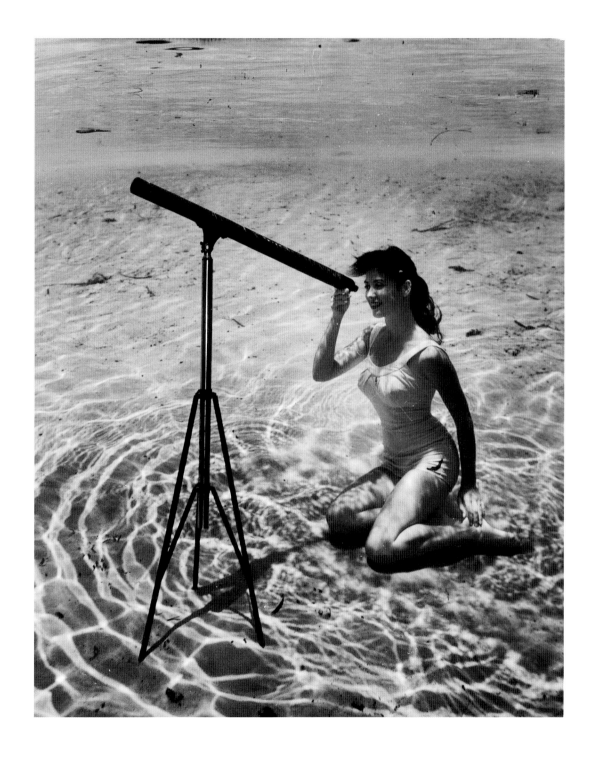

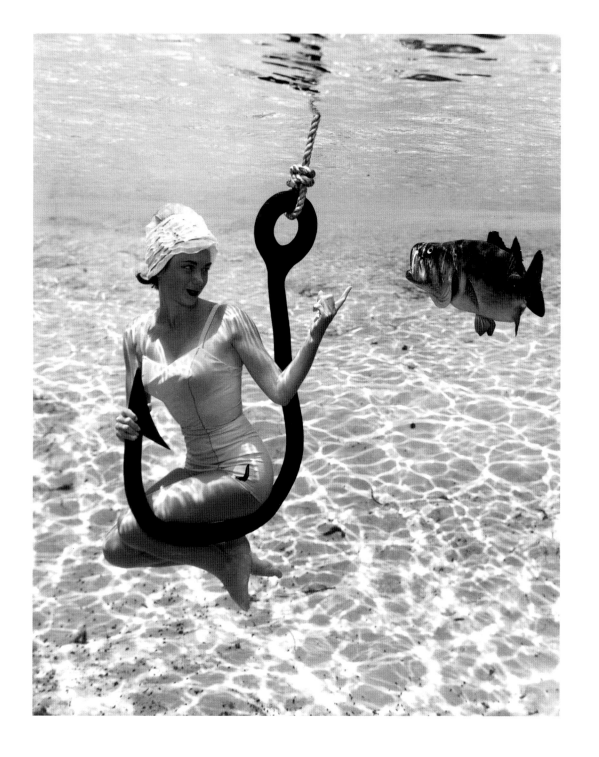

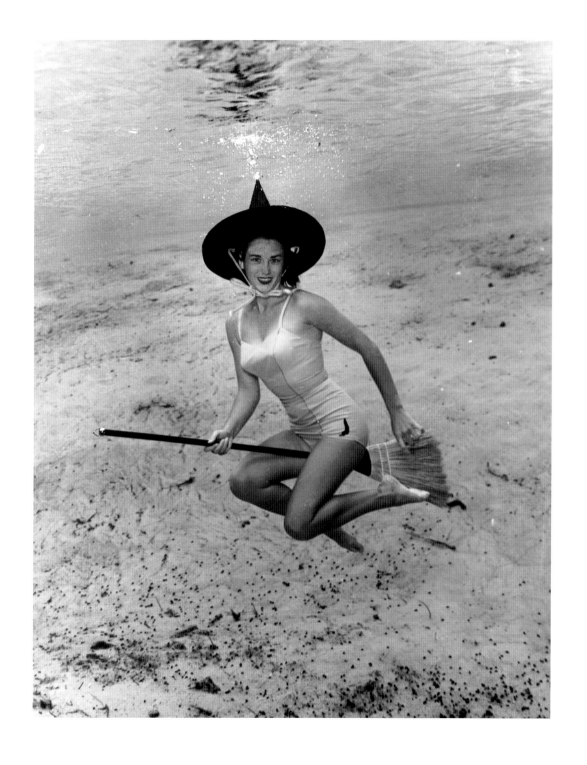

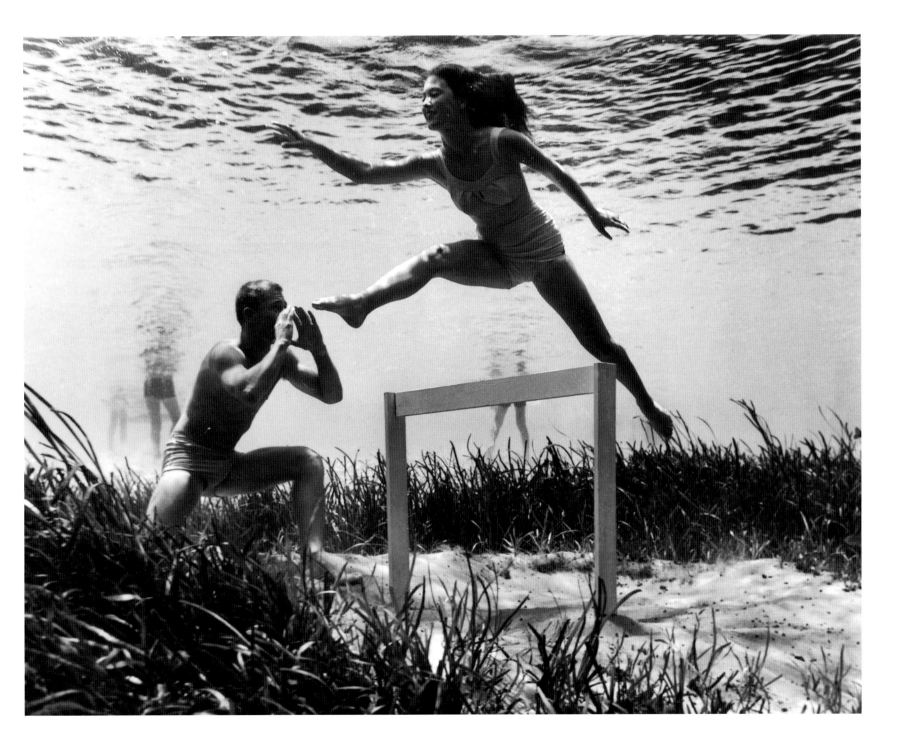

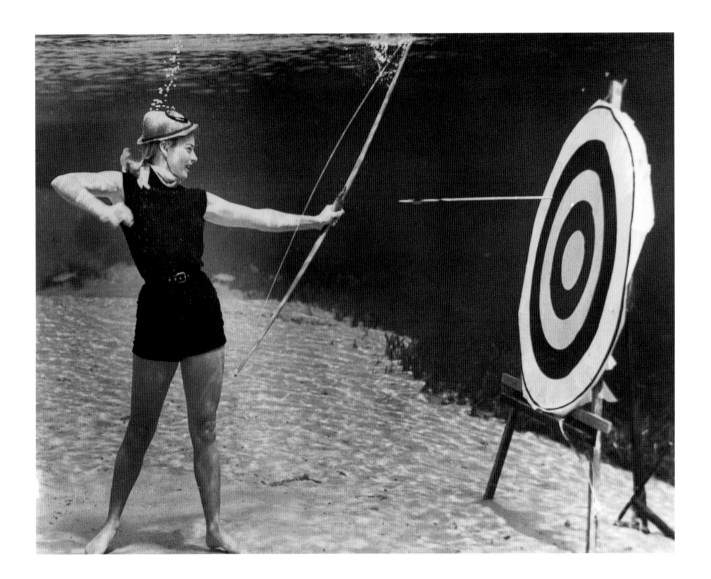

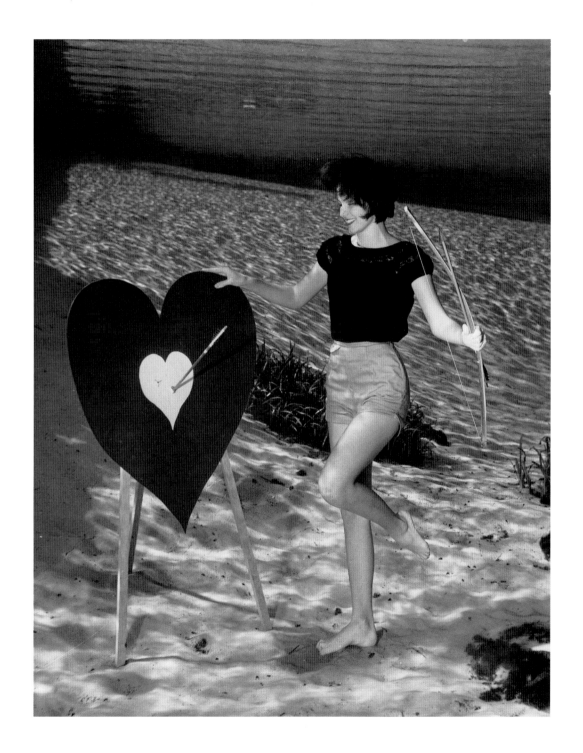

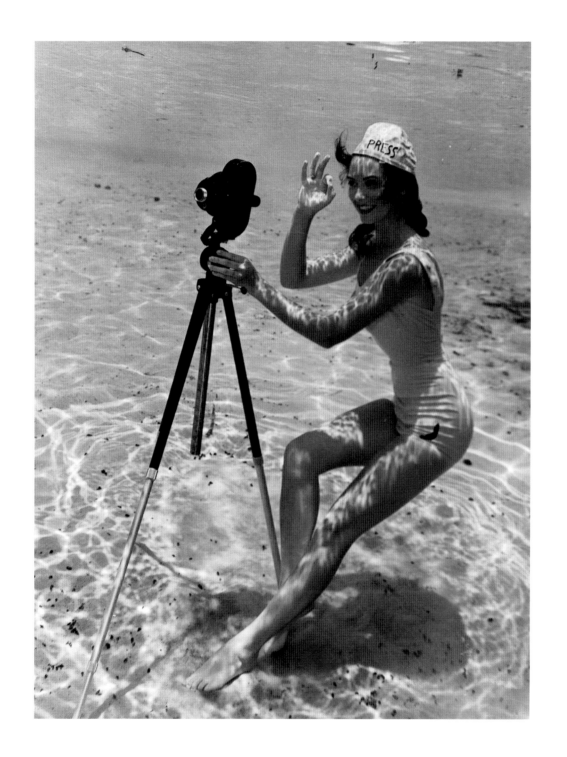

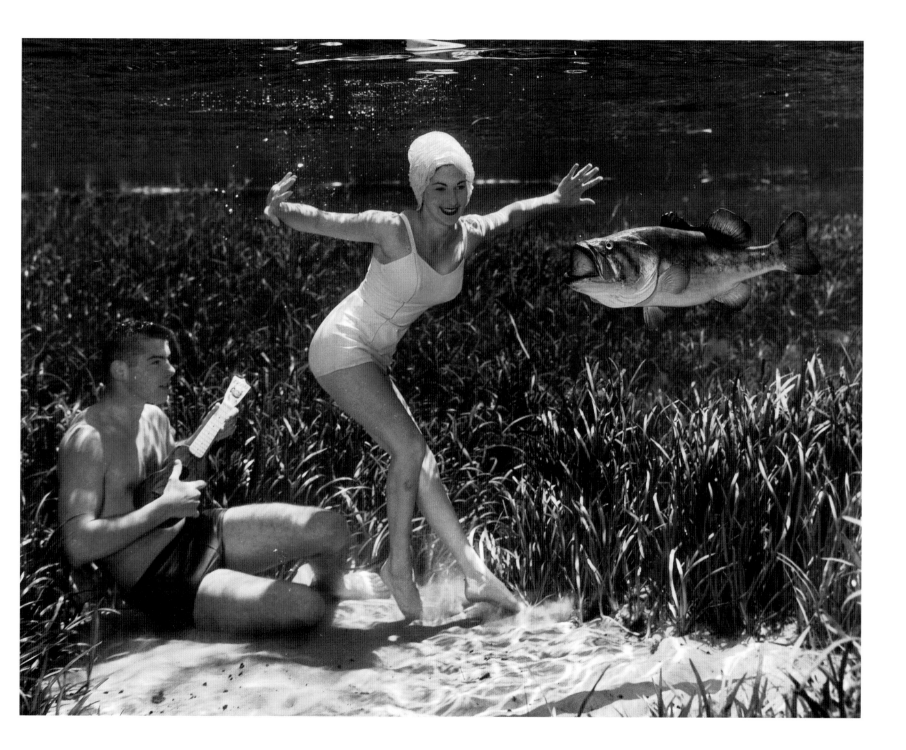

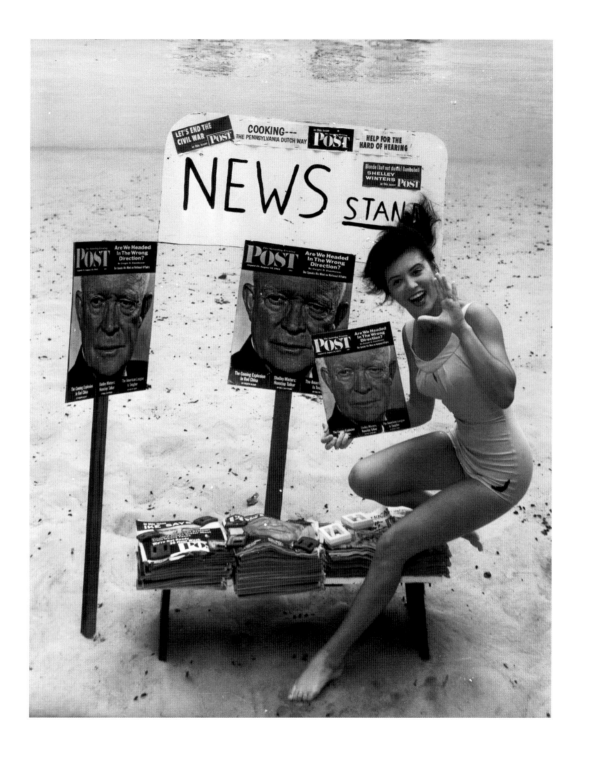

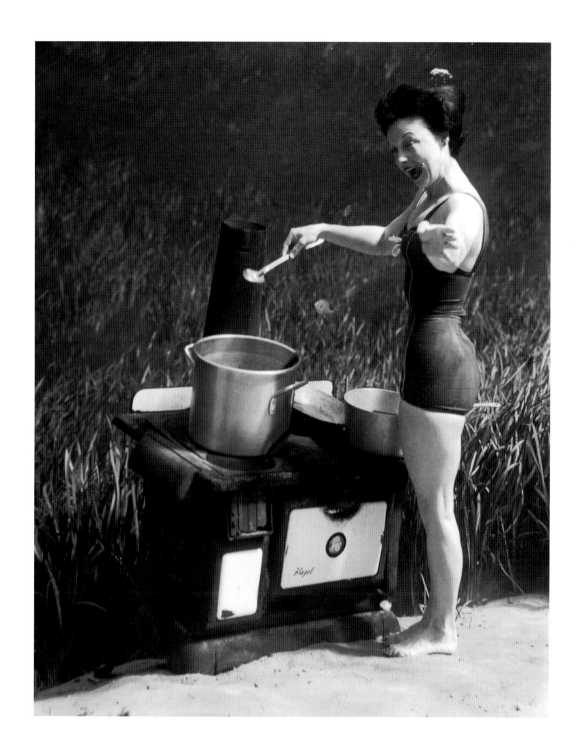

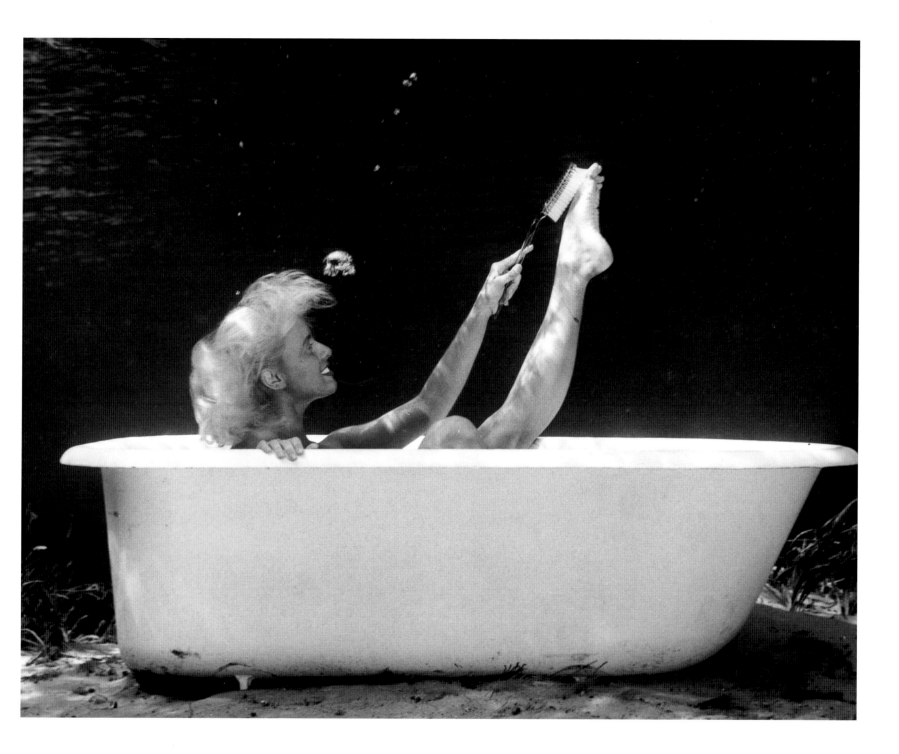

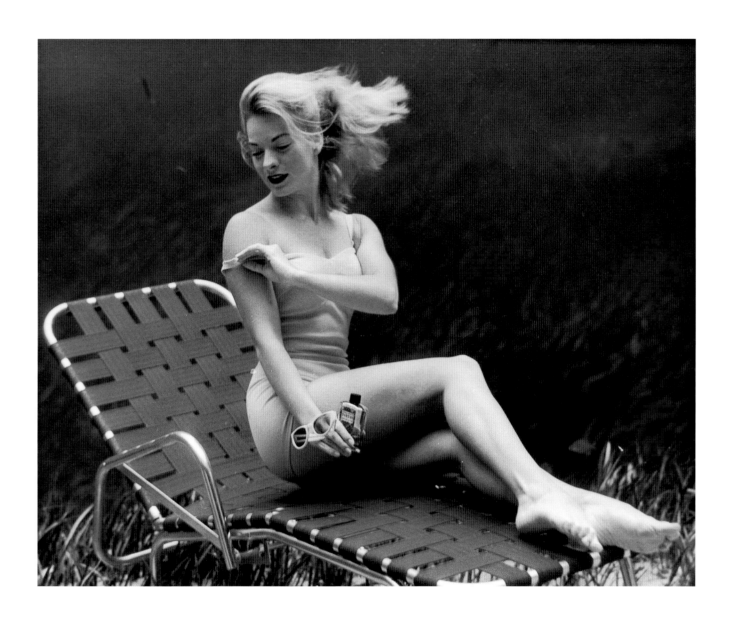

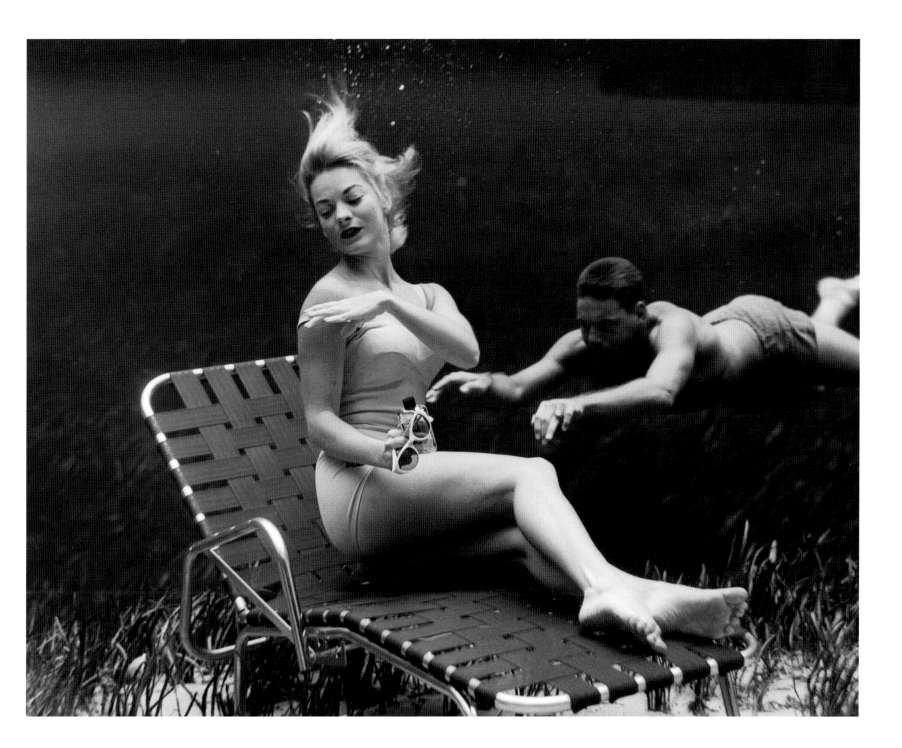

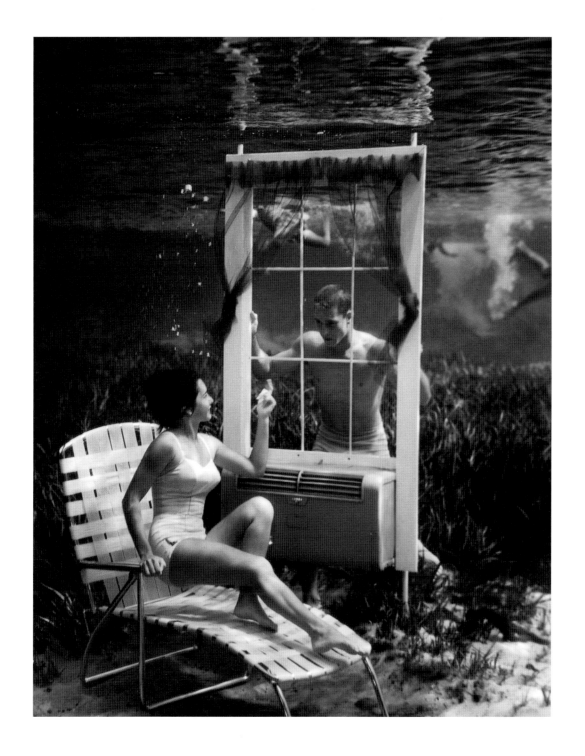

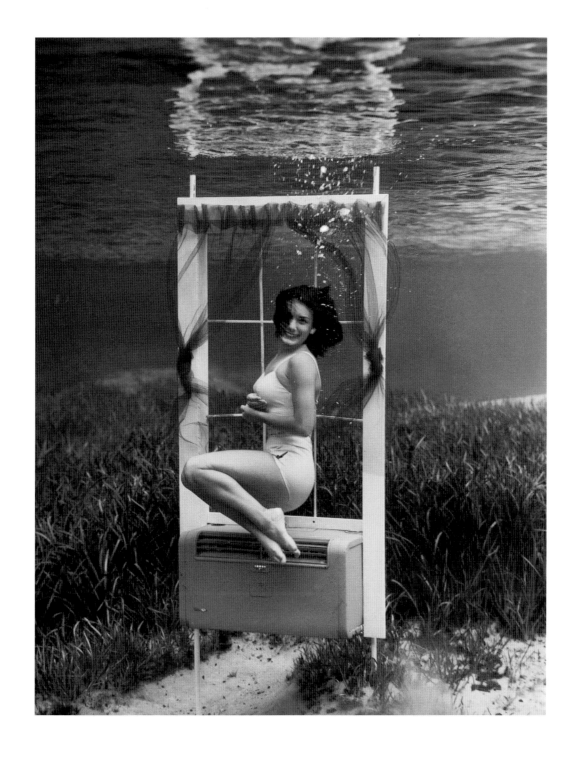

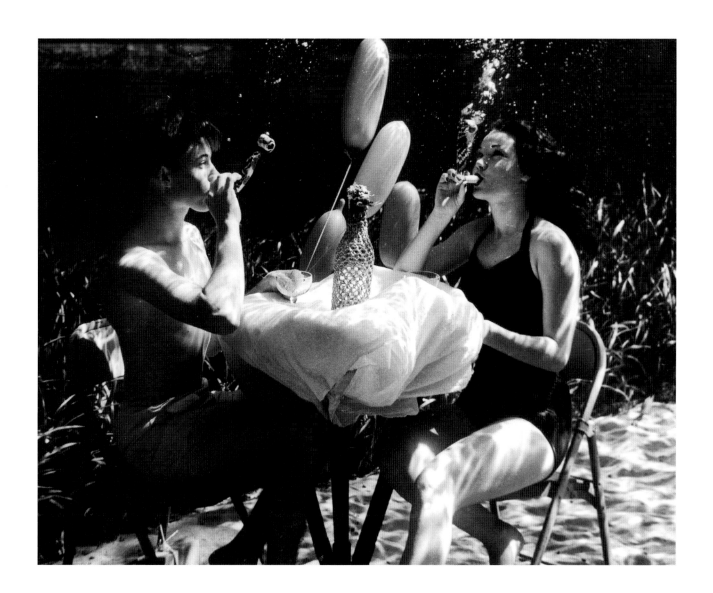

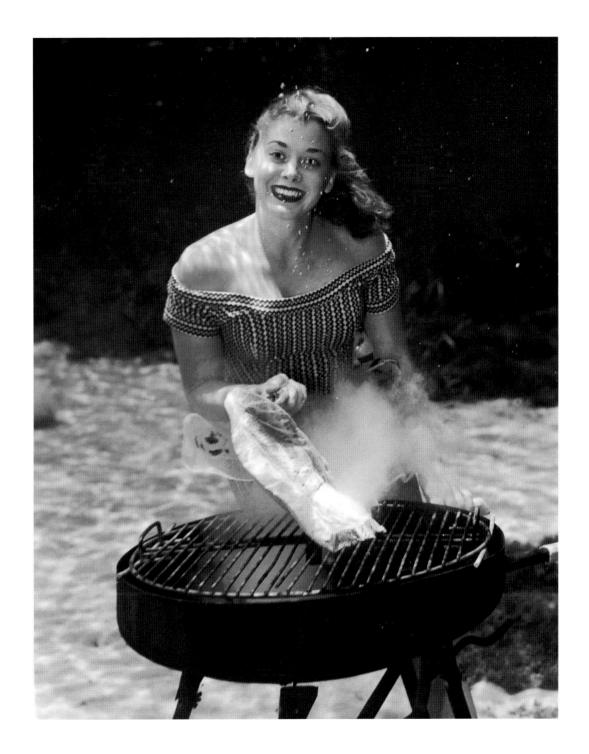

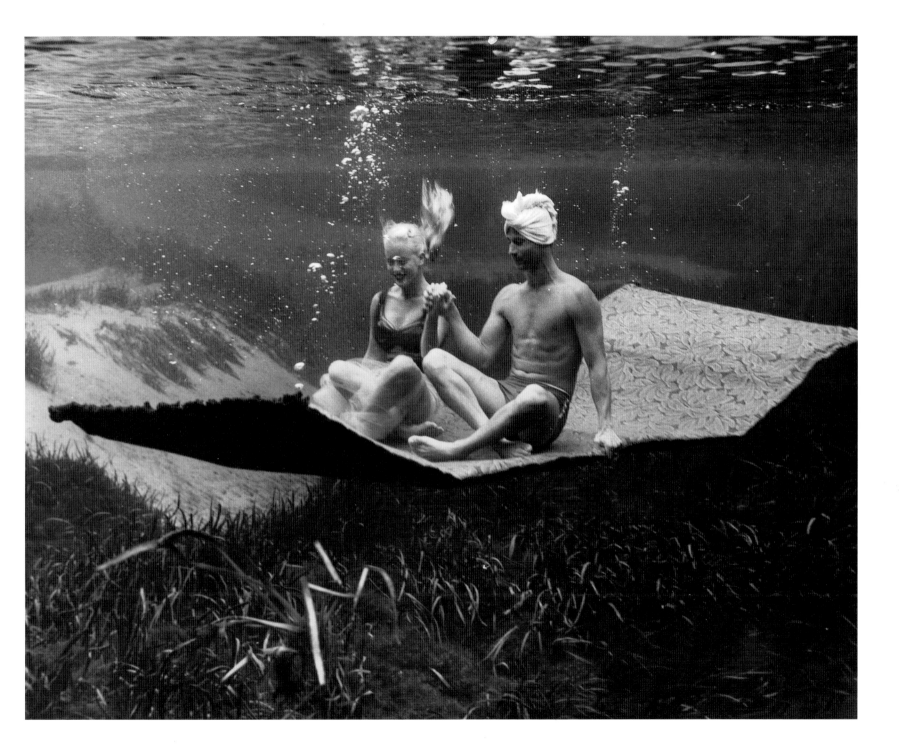

After college, Gary Monroe returned home to photograph the old world culture of Miami's South Beach. Grants from the National Endowment for the Arts, the Cultural Affairs Division of Florida's State Department, Florida Humanities Council, and the Fulbright Program have supported his photography. Mr. Monroe has traveled to photograph in Brazil, Israel, Spain, Cuba, India, Trinidad, and Poland.

His long-time fascination with outsider and vernacular art has led Mr. Monroe into writing about nontraditional Florida art. His books include *The Highwaymen: Florida's African-American Landscape Painters*, *Extraordinary Interpretations: Florida's Self-taught Artists*, and *Harold Newton: The Original Highwayman*. For more information about Gary Monroe's photography and publications, please visit his Web site at www.gary-monroe.net.